ON THE COVER: Wilkes-Barre Wheelmen Club photographer Erskine L. Solomon took this picture of other club members during a trip to the Wyoming Monument on July 4, 1896. The cornerstone for the 62.5-foot monument was laid in 1833. The Wyoming Monument was completed in 1843, and it serves as a memorial and tomb for the 175 Americans who were killed in the Battle of Wyoming and during the Wyoming Massacre on July 3, 1778. Nearly 375 Americans led by Col. Zebulon Butler (1731–1795) and Col. Nathan Denison (1741–1809) fought British forces, including Tories and Native Americans. Among the Americans killed were Capt. James Bidlack Jr., Lt. Col. George Dorrance, Capt. Robert Durkee, Maj. John Garrett, Ens. Asa Gore, Lt. Elijah Shoemaker, Lt. Asa Stevens, and Ens. William White. Colonel Denison was forced to surrender the Wyoming Valley to the British on July 4, 1778. British-allied Native Americans raided, looted, and burned colonial settlements throughout the valley. Five-year-old Frances Slocum (1773–1847) was kidnapped by Lenape on November 2, 1778, and she was not seen by her family again until 1837. (Courtesy Luzerne County Historical Society.)

IMAGES of America
LUZERNE COUNTY

Harrison Wick for the
Luzerne County Historical Society

ARCADIA
PUBLISHING

Copyright © 2011 by Harrison Wick for the Luzerne County Historical Society
ISBN 978-0-7385-7378-7

Published by Arcadia Publishing
Charleston, South Carolina

Printed in the United States of America

Library of Congress Control Number: 2010927047

For all general information, please contact Arcadia Publishing:
Telephone 843-853-2070
Fax 843-853-0044
E-mail sales@arcadiapublishing.com
For customer service and orders:
Toll-Free 1-888-313-2665

Visit us on the Internet at www.arcadiapublishing.com

This book is dedicated to my great aunt Sally Bruce McClatchey.

CONTENTS

Acknowledgments		6
Introduction		7
1.	Businesses and Street Scenes	9
2.	Education and Religious Life	43
3.	Coal Culture	57
4.	Disasters	73
5.	Entertainment and Social Organizations	87
6.	Government and Military Service	101
7.	Transportation	111
Bibliography		127

Acknowledgments

Luzerne County was made possible by the Luzerne County Historical Society. I want to thank executive director Anthony T. P. Brooks and director of library and archives Amanda Fontenova. Founded as the Wyoming Historical and Geological Society on February 11, 1858, the historical society is located on South Franklin Street in Wilkes-Barre. I want to acknowledge the Back Mountain Historical Association, Dallas Rotary Club, King's College, the Lands at Hillside Farms, Luzerne County Community College, the Luzerne County Library System, Misericordia University, the Religious Sisters of Mercy, St. Nicholas Church, the West Pittston Historical Society, Wilkes University, and Wyoming Seminary.

Many people throughout Luzerne County have contributed to this work, including Joan Coolbaugh Britt, William H. Conyngham, Judith Simms Dawe, Wilhelmina Estock, Howard and Lillian Gola, Louise Schooley Hazeltine, Florence Matura Hozempa, Stephen B. Killian, Harold H. Kishbaugh, Michael A. MacDowell, Jack Martin, Harold D. Owens Jr., Sandra Panzitta, F. Charles Petrillo, Mary Portelli, Msgr. Joseph G. Rauscher, Jessica Reeder, Pauline Shaver Roth, Marilyn Rozelle, Roger Samuels, Donna Snelson, Bill Strauser, Julie McCarthy Strzeletz, Carol Wall, William Wentz, and the late Edward S. Miller. Without their contributions, this book would not have been possible.

Unless otherwise noted, all images are courtesy of the Luzerne County Historical Society.

INTRODUCTION

Luzerne County offers a rich tapestry of images that chronicle the history, diverse culture, and ethnic heritage in the many boroughs, townships, and villages throughout the county. Early settlement of the area led to the Pennamite-Yankee Wars between 1769 and 1786, when land claims were disputed by colonists from Pennsylvania and Connecticut. The Susquehanna Company of Connecticut was formed to settle the Wyoming Valley. In 1769, five townships including Kingston, Nanticoke, Pittston, Plymouth, and Wilkes-Barre were formed. Wilkes-Barre, named for parliamentarians John Wilkes (1727–1797) and Isaac Barré (1726–1802), was first settled by colonists from Connecticut led by Maj. John Durkee (1728–1782) in 1769.

Luzerne County was created from Northumberland County, Pennsylvania, on September 25, 1786. The county was named for Chevalier de la Luzerne (1741–1791), the French minister to the United States from 1778 to 1784. Wilkes-Barre became the county seat, and it was incorporated as a borough on March 17, 1806. From the 18th century through the 20th century, Europeans came to Luzerne County from England, Scotland, Wales, Ireland, and Germany, then later from Austria, Croatia, Hungary, Italy, Lebanon, Lithuania, Poland, Russia, Slovenia, Syria, and the Ukraine. Today Luzerne County covers 907 square miles, but the county originally extended to the New York border when it included what would become Bradford (1810), Susquehanna (1810), Wyoming (1842), and Lackawanna (1878) Counties.

A region historically known for mining coal, Luzerne County is part of the anthracite coal fields of Pennsylvania that also include Carbon, Columbia, Dauphin, Lackawanna, Northumberland, and Schuylkill Counties. The first coal prospectors were Abijah Smith and Freeman Thomas, who opened mines in Plymouth Township. Luzerne County judge Jesse Fell (1751–1830) first experimented with burning anthracite coal on February 11, 1808. During the War of 1812, anthracite coal was selling for $17 per ton in New York City due in part to marketing by Jacob Cist. As the population of Luzerne County grew, Wilkes-Barre was incorporated as a city on May 4, 1871. Coal fueled the American Industrial Revolution, and for more than a century, the regional economy was dependent on coal mining. The Knox Mine Disaster of 1959 ended the dominance of the anthracite coal industry in Luzerne County.

WILLIAM SWETLAND AND COMPANY, 1845. In 1815, local merchant William Swetland (1789–1864) opened a store near the Swetland Homestead in Wyoming. The advertisement printed in October 1845 promoted the company's inventory of food, dry goods, and supplies for the fall and winter months. William Swetland and Company sold building materials; medicines; boots and shoes; clothing and fine cloth; fashionable hats; kettles; stoves; hardware, iron, nails, and steel; salt by the barrel; molasses and sugar; smoked and salted meats; and alcohol. Prices for men's boots ranged from $1.50 to $1.75, women's boots were 75¢ to $1, and fur hats were $1.50 to $4. William Swetland inherited the Swetland Homestead, built in 1803 by his grandfather Luke Swetland (1729–1823) who came from Connecticut. The Swetland Homestead, located at 885 Wyoming Avenue, is approximately one mile from the Nathan Denison House (built in 1790) in Forty Fort. Today both houses are maintained by the Luzerne County Historical Society.

One
BUSINESSES AND STREET SCENES

WILKES-BARRE CITY HOSPITAL, 1876. The Wilkes-Barre City Hospital opened a 20-bed facility in a rented building on Fell Street on October 10, 1872. This facility soon proved inadequate, but in 1875, four acres on North River Street was donated by John Welles Hollenback (1827–1923) for the construction of a new building. A two-story 60-bed hospital opened on April 1, 1876, across from the Hollenback Cemetery that was named for George Matson Hollenback (1791–1866). The hospital operated a School of Nursing from 1887 to 1974. In 1923, the Wilkes-Barre City Hospital became the Wilkes-Barre General Hospital.

FIRST NATIONAL BANK IN WILKES-BARRE, C. 1870. The building stood opposite the third Luzerne County courthouse on Public Square between East Market Street and South Main Street. The First National Bank was designed and built by New York architect Isaac G. Perry (1822–1904), who outlined many corporate buildings and residences in Wilkes-Barre. The First National Bank occupied the building until 1908. It was remodeled by architects Alfred Hamilton Kipp and Thomas Podmore, and became the Savoy Theatre. Other financial institutions in Wilkes-Barre included the Second National Bank, organized in September 1863; the Miners National Bank opened in 1868; the Peoples Bank of Wilkes-Barre, organized in 1871; and the Wyoming Valley Trust Company, established in 1906.

BOSTON STORE EMPLOYEES, 1893. In March 1879, Scottish immigrants Fowler, Dick, and Walker opened the Boston Store on South Main Street in Wilkes-Barre. Among the store's early employees was Anthony Richardson, who belonged to the Golden Rule Lodge No. 15. In 1904, the store started offering horseless carriage delivery service. Fowler became the Boston Store's sole proprietor when cofounder Gilbert Walker died in 1908. The store later became Boscov's Boston Store.

WYOMING VALLEY HOTEL, 1900. J. B. Stark was the proprietor of the Wyoming Valley Hotel when the photograph was taken. In 1897, architect Alfred Hamilton Kipp and builder E. W. Sturdevant remodeled the six-story hotel on South River Street in Wilkes-Barre. The hotel replaced the Phoenix Hotel that was demolished in 1865. The Wyoming Valley Hotel, designed by Philadelphia architect J. C. Sidney, opened on March 29, 1866. Mark Twain (1835–1910) stayed at the hotel while visiting Wilkes-Barre to give a lecture on October 10, 1871.

WELLES BROTHERS, 1886. The photograph of the surviving sons of Eleanor Hollenback Welles (1788–1876) and Charles Fisher Welles (1789–1866) was taken on January 21, 1886. In the photograph are, from left to right, (seated) John Welles Hollenback, George Hollenback Welles (1822–1909), Matthias Hollenback Welles, and Rev. Henry Hunter Welles (1824–1902); (standing) Edward Welles (1832–1914) and Raymond Marion Welles. In 1862, John Welles was adopted by his uncle George Matson Hollenback and became known as John Welles Hollenback.

JONAS LONG'S AND SONS STORE EMPLOYEES, 1890. The store opened at the corner of West Market Street on Public Square in 1860. The picture was taken before the Jonas Long's and Sons Department Store was replaced with a five-story building in 1895, which became Pomeroy's Department Store at 2 Public Square. The City of Wilkes-Barre renovated the building that closed in 1987 to become the Greater Wilkes-Barre Chamber of Commerce building.

W. D. Beers Grocery Delivery Wagon, 1890. Above is the W. D. Beers Grocery Store located at 7 West Market Street in Wilkes-Barre. The wagon driver and his dog are sitting in one of the company's horse-drawn delivery wagons that delivered groceries throughout Wilkes-Barre. Before refrigeration, delivery wagons were packed with straw and ice.

A. Weitzenkorn and Sons Clothiers, 1890. According to Luzerne County legal registers, clothing store owners Joseph K. Weitzenkorn and Benjamin Weitzenkorn wanted to expand their business and leased 6 South Main Street in Wilkes-Barre for the annual rent of $5,000 in 1894. The rented property was adjacent to the existing Weitzenkorn clothing business. Their company was successful, and the lease was renewed for $8,000 on January 30, 1913.

FELL TAVERN IN WILKES-BARRE, C. 1880. On February 11, 1808, Judge Jesse Fell conducted the first experiment burning anthracite coal. According to Fell, he "made the experiment of burning the common stone coal of the valley in a grate, in a common fireplace in [his] house, and found it will answer the purpose of fuel, making a clearer and better fire, at less expense, than burning wood in the common way." Fell Tavern was built near the corner of East Northampton Street and South Washington Street in 1787.

GRAND OPERA HOUSE IN HAZLETON, 1896. The Grand Opera House on Broad Street and Vine Street was rebuilt after a fire on May 14, 1892. This photograph was taken from Broad Street on April 30, 1896. Presidential candidate William Jennings Bryan (1860–1925) spoke there on April 21, 1898. A vote was cast at the Grand Opera House on May 13, 1902, and 147,000 United Mine Coal Workers of America (UMWA) members went on strike during the Coal Strike of 1902, causing 357 collieries to close for 151 days.

HARVEY'S CREEK HOTEL, 1900. R. H. Stout was the hotel proprietor at the time this photograph was taken. In 1830, the Wyoming Division of the North Branch Canal of the Pennsylvania canal system was completed to Nanticoke. In 1832, Daniel Carey built a large house near the canal that was moved to West Nanticoke by Joseph Edwards and George Mark in 1839. The house became the Harvey's Creek Hotel that was first owned by James J. Ruch.

HOLLENBACK COAL EXCHANGE BUILDING, 1896. This building was constructed in 1889 on the site of the Hollenback House, which was erected by Matthias Hollenback (1752–1829) on South River Street next to the Wyoming Valley Hotel. Across Market Street on the left –was the music hall that was demolished to build the Hotel Sterling. Four additional floors were added to the six-story Hollenback Coal Exchange Building in 1907. The American flags hanging above Market Street had campaign slogans for Pres. William McKinley (1843–1901) and his first vice president, Garret Hobart (1844–1899).

NESBITT HOSPITAL, C. 1912. Philanthropist Abram Nesbitt (1831–1920) purchased the former Charles Dorrance residence on Wyoming Avenue in Kingston to create a hospital. This image was taken after a new wing was added to the building. The Nesbitt West Side Hospital opened as a 30-bed facility on October 7, 1912. Nesbitt continued to support the hospital, and a larger facility was built in 1927–1928. The Nesbitt Memorial Hospital became part of the Wyoming Valley Health Care System in 1992.

DRIVING ON SOUTH RIVER STREET, C. 1902. The photograph was taken in front of the Wyoming Valley Hotel. Behind the driver in the second row are, from left to right, Robert Sigmund, Josephine Courtright, Ethel Walker Arch, and George Welsh Arch. On the end of the third row is Ruth Courtright, and on the end of the back row is William F. Luckenback. In 1909, the Wyoming Valley Hotel was demolished to build the Lehigh and Wilkes-Barre Coal Company Office.

BANQUET FOR HENRY M. HOYT, 1878. The banquet was held at the Wyoming Valley Hotel on New Year's Eve in honor of governor-elect Henry Martyn Hoyt (1830–1892). In 1861, Hoyt helped recruit the 52nd Pennsylvania Volunteer Infantry Regiment, nicknamed the Luzerne Regiment since many of the soldiers came from Luzerne County. In July 1864, Confederates near Charleston, South Carolina, captured 135 soldiers of the 52nd Regiment led by Colonel Hoyt. Henry Hoyt was inaugurated as governor in January 1879.

CHARLES W. MATHESON AND JOHN WELLES HOLLENBACK, 1910. In the photograph above, Charles W. Matheson (1877–1940) is driving with John Welles Hollenback in a 1909 Matheson Silent Six with 50 horsepower and a 128-inch wheelbase. In 1902–1903, Charles W. Matheson and his brother Frank started the Matheson Motor Car Company in Grand Rapids, Michigan. Matheson produced one of the first engines with overhead valves. In 1905–1906, the company office moved to Wilkes-Barre and manufactured automobiles in Forty Fort until 1912.

TROLLEY COMPANY OFFICE IN WILKES-BARRE, 1906. The image above of the Wilkes-Barre and Wyoming Valley Traction Company office building was taken across South Main Street by Ralph E. Dewitt as he stood between Morgan's Hardware and Ben Dilley's Saloon. The building was decorated for the Wilkes-Barre Centennial celebration, from May 10 through May 12 in 1906. The Wilkes-Barre and Wyoming Valley Traction Company was incorporated on February 9, 1891. The company general manager was Thomas A. Wright, and the company property was leased to the Wilkes-Barre Railway in 1909.

MAP OF LUZERNE COUNTY, C. 1791. Original borders for the county extended to the New York border, and the county included areas that are now part of Bradford County, Lackawanna County, Susquehanna County, and Wyoming County. Visible on the map were the settlements in Berwick and Wilkes-Barre and the Susquehanna River, Bowman's Creek, Wyoming Falls, Nanticoke Falls, and Nescopeck Falls.

STEGMAIER GOLD MEDAL BEER, 1914. This advertisement featured bartenders Mike Mazonkey and Simon Balchun at Balchun's Cafe in Shickshinny. The Baer and Stegmaier Brewery opened in 1857 on South Canal Street in Wilkes-Barre through a partnership between German immigrant Charles Stegmaier (1821–1906) and his father-in-law, George Baer. Stegmaier Brewing Company was incorporated in 1897. Stegmaier beer earned eight gold medals at expositions in Rome, Antwerp, and Vienna from 1911 to 1913.

SHICKSHINNY AND MOCANAQUA LOOKING SOUTH, 1960. Above is the bridge connecting Shickshinny and Mocanaqua (State Route 239) and Main Street (Route 11). Shickshinny was named for Shickshinny Creek, where mountains including Newport, Knob, Lee, River, and Rocky meet along the Susquehanna River. The first settlers to the area included the Austin family from Connecticut. Coal was discovered at Rocky Mountain in 1830, and early coal shipments were transported by canal boat.

TROLLEY ON CAREY AVENUE IN WILKES-BARRE, 1889. Scranton was first called the Electric City in 1886 after establishing one of the first electric trolley systems in the country. The photograph showed Wilkes-Barre and Suburban Street Railway Trolley No. 5 on Carey Avenue along the Parsons, Miners Mills, and Plains line. The first electric trolley in Wilkes-Barre ran on North Main Street on March 19, 1888.

W. D. Beers Grocery Delivery Trucks on West Market Street, 1925. The W. D. Beers building was prominent in the Wilkes-Barre business district at 7 West Market Street. In addition to the W. D. Grocery Store, the building offered rooms for rent and a host of other businesses such as the Jade Beauty Parlor, Charles Rose Gold Buying Service, and Jordan's clothing Store.

Percy A. Brown Grocery Store, 1926. The full service grocery store was in the middle of Northampton Street near South Main Street in Wilkes-Barre. The grocery store offered fresh produce, a butcher shop, and a cafeteria that served three meals a day. Wilkes-Barre Movies 14 was built on the site of the grocery store. Percy Brown was born in Butler Township in 1883, and his parents moved to Wilkes-Barre when he was six years old.

POMEROY'S DEPARTMENT STORE AT 2 PUBLIC SQUARE, 1930. In 1876, George Pomeroy, Josiah Dives, and James Stewart from Connecticut invested $1,000 in a store named the Globe in Reading. Their enterprise expanded into Pomeroy's Department Store, and the Wilkes-Barre store became one of Pomeroy's flagship stores. The five-story building was designed with a three-story entrance arch by New York architect Peter J. Lauritzen (1847–1934) for the Jonas Long's and Sons Department Store in 1895.

STREAMLINE AEROCYCLE SOLD BY HENRY PLATT, 1930. Henry Platt began selling bicycles at 126 East Broad Street in Hazleton. The Streamline Aerocycle was manufactured in Chicago by Arnold, Schwinn and Company founded in 1895. This photograph shows the Streamline Aerocycle being sold by Henry Platt at his bicycle store at 427 Samuels Avenue in Hazleton.

WEISS GARAGE AND NASH AUTO SALES AND SERVICE, 1930. Weiss Garage in Hazleton was a full service garage and sold Sinclair gasoline. The garage was equipped to handle AAA service, insurance claims, towing, engine service, battery replacement, and mechanical work for all automotive makes and models. All Nash models were sold, including coupes, pickup trucks, sedans, and work trucks.

WEST SIDE AUTO COMPANY AT KINGSTON CORNERS, 1930. The store at 642 Wyoming Avenue offered Ford and Lincoln sales and service. The West Side Auto Company was at the intersection of Market Street and Wyoming Avenue in Kingston. Next door was Williams Radiator Repair Work. The West Side Auto Company offered night repair service. In 1930, a new battery cost $7.25 with an exchange.

PENN TOBACCO COMPANY EMPLOYEES, 1938. The company was located at South Main Street and Dana Street in Wilkes-Barre. In 1901, the factory, consisting of one cutting machine valued at $750, only had eight employees. The first company superintendent was Henry Weigand, who later became company president. The company made Kentucky Club and Willoughby Taylor smoking tobaccos and Penn's Stripped, a long-cut chewing tobacco. The Penn Tobacco Company was sold to the Bloch Brothers Tobacco Company of Wheeling, West Virginia, in 1943.

PLANTERS PEANUTS, 1947. In the 1890s, Italian immigrant Amedeo Obici (1877–1947) came to Wilkes-Barre. Obici and business partner Mario Peruzzi founded the company in 1906 on South Main Street in Wilkes-Barre. In 1913, Planters Peanuts purchased a peanut cleaning plant in Suffolk, Virginia. The company held a contest in 1916 to create a company logo, and 14-year-old Antonio Gentile won with his drawing of a peanut man. Mr. Peanut became a registered trademark on March 3, 1925.

GOODWILL FIRE COMPANY ON PUBLIC SQUARE, 1864. Wilkes-Barre Councilman Charles Miner (1780–1865) made a motion to appoint a committee to explore the possibility of purchasing fire fighting equipment on March 31, 1807. In 1837, the first fire department building constructed in Wilkes-Barre on Franklin Street housed the newly purchased Reliance fire engine.

MERCY HOSPITAL IN WILKES-BARRE, 1900. The Religious Sisters of Mercy were founded in 1831 by Catherine McAuley (1778–1841) in Dublin, Ireland. In the 1870s, the RSM came to the Wyoming Valley from Pittsburgh. Mercy Hospital in Wilkes-Barre opened on March 7, 1898. Medical care was free at the hospital until 1911, when donations became insufficient to cover expenses. The hospital also offered a two-year School of Nursing program. In 2005, Mercy Hospital became Geisinger South Wilkes-Barre.

VIEW FROM PUBLIC SQUARE, 1875. Buildings between South Main Street and East Market Street included Wilson and Barber Drugs and Medicines on the far left, the First National Bank, the Wilkes-Barre Savings Bank, *Record of the Times* newspaper printing office, bookbindery, livery stable office, the Friendship Saloon, and the Bristol House. These buildings were across from the Luzerne County Courthouse on Public Square. Wilkes-Barre was a distribution hub for the Lehigh Valley Railroad; Central Railroad of New Jersey; the Delaware, Lackawanna and Western Railroad; the Delaware and Hudson Railroad; the Pennsylvania Railroad; the Wilkes-Barre and Eastern Railroad; and the Lackawanna and Wyoming Valley Railroad.

BETWEEN EAST MARKET AND SOUTH MAIN STREET ACROSS FROM PUBLIC SQUARE, 1875. Buildings included the S. B. Moore building, a cigar and tobacco shop, Oliver Bookbindery and Stationery Store, a bakery, and bank. Note the large wooden ledger display in front of the carriage advertising the bookbindery. To the far right on the corner of South Main Street was Central Express Tailoring, offering mechanized tailoring and steam pressing.

VIEW FROM PUBLIC SQUARE, 1878. Buildings between North Main Street and East Market Street included the four-story Exchange Hotel with covered balconies in the center and A. R. Devers and Company. In 1869, Milton Hannum sold the *Record of the Times* newspaper to Walter H. Hibbs from Philadelphia. The newspaper was moved to the building adjoining the Exchange Hotel. Shortly before he retired from the newspaper business in 1871, Walter H. Hibbs took H. B. Beardslee as a partner.

CENTENNIAL ARCH ON WEST MARKET STREET, 1878. The arches were decorated for the centennial of the Battle of Wyoming and Wyoming Massacre that took place on July 3, 1778. On the left is the music hall built by Isaac G. Perry in 1870. On the right is the Hollenback House built by Matthias Hollenback, who came to the Wyoming Valley in 1769 and became one of the wealthiest men in Northeastern Pennsylvania.

BETWEEN WEST MARKET AND NORTH MAIN STREETS IN WILKES-BARRE, 1879. Buildings across from Public Square included the Jonas Long's and Sons Store annex that sold jewelry, dry goods, carpets, millinery, and sporting goods. To the right there were storefronts owned by N. Eisen; H. Huether, who sold boots, shoes, and hosiery; and the Weitzenkorn and Sons clothing store.

VIEW OF WEST MARKET STREET FROM PUBLIC SQUARE, 1885. This photograph was taken from the Luzerne County Courthouse looking towards the entrance to the covered Market Street Bridge. Storefronts included a cable and telegraph office, cigar and tobacco store, the Jonas Long's and Sons Department Store, and a hardware store.

MILL HOLLOW COLLIERY, 1890. In May 1866, the Mill Hollow Colliery was established in Luzerne, named for the four mills operated on Toby's Creek. The image above shows what became Main Street in Luzerne and the water-powered gristmill on Toby's Creek that became Luzerne Lumber at 445 Main Street. The breaker in the background was owned by the Raub Coal Company. In 1889, the Mill Hollow Colliery was owned by Thomas Waddell and Company. The colliery had 289 employees who worked 217 days in the shaft that year. In 1889, Mill Hollow Colliery's total output was 103,657 tons, and the gross tonnage for railroad shipment was 99,099 tons of coal. A native of Pittston, Thomas Waddell relocated to Ohio and died in 1916. The general manager of the Mill Hollow Colliery was E. Straup, who bought the property from the Waddell estate.

VIEW FROM COURTHOUSE ON PUBLIC SQUARE, 1887. Pictured above is the intersection of South Main Street and the Susquehanna River in the background. Hunts' Hardware was on South Main Street. Buildings between South Main Street and West Market Street were the Public Square Hotel operated by Frank Bresslen; Kline's Chinese Palace; Joseph Coons and Son Store, which sold clothing, dry goods, and furnishings; and the Welles building, which had the first passenger elevator in Wilkes-Barre.

WILKES-BARRE LOOKING TOWARDS WEST MARKET STREET, 1887. This photograph, taken from the third floor of the Luzerne County Courthouse on Public Square, looks towards the covered bridge and the Kingston flats. Visible at the end of West Market Street is the Hendrick B. Wright ticket office, which was adjacent to the Hollenback House on South River Street.

Wilkes-Barre Area Population, 1922. In 1920, there were 391,000 people living in Luzerne County, with 15,286 in Kingston and 75,810 in Wilkes-Barre. The population of Luzerne County peaked at 445,109 in 1930. The map identified railroads, including the Lehigh Valley Railroad. The LVRR had a fleet of passenger trains including the *Black Diamond*, *Lehigh Limited*, *John Wilkes*, and *Asa Packer* in service between Wilkes-Barre and New York City. The *Black Diamond* was in service from May 18, 1896, to May 11, 1959.

CONYNGHAM HOUSE IN WILKES-BARRE, 1890. This house at 128 West South Street was owned by William Lord Conyngham (1829–1907) and his wife, Olivia Hillard Conyngham; however, the house was vacant after her death in 1918. The Conyngham family offered the house to the Religious Sisters of Mercy after their motherhouse, St. Mary's Convent in Wilkes-Barre, was destroyed by a fire on March 21, 1920. They remained in the house until College Misericordia opened in 1924.

FIRE ON SOUTH MAIN STREET, 1892. This photograph was taken after the volunteer fire company had doused the flames in Wilkes-Barre. The fire damaged several buildings and completely gutted the Weiss Hotel, destroying the roof and second floor. Volunteer fire companies in the 19th century owned fire fighting equipment that often consisted of a horse-drawn hose cart. By the early 1900s, most suburban fire departments were equipped with company trucks.

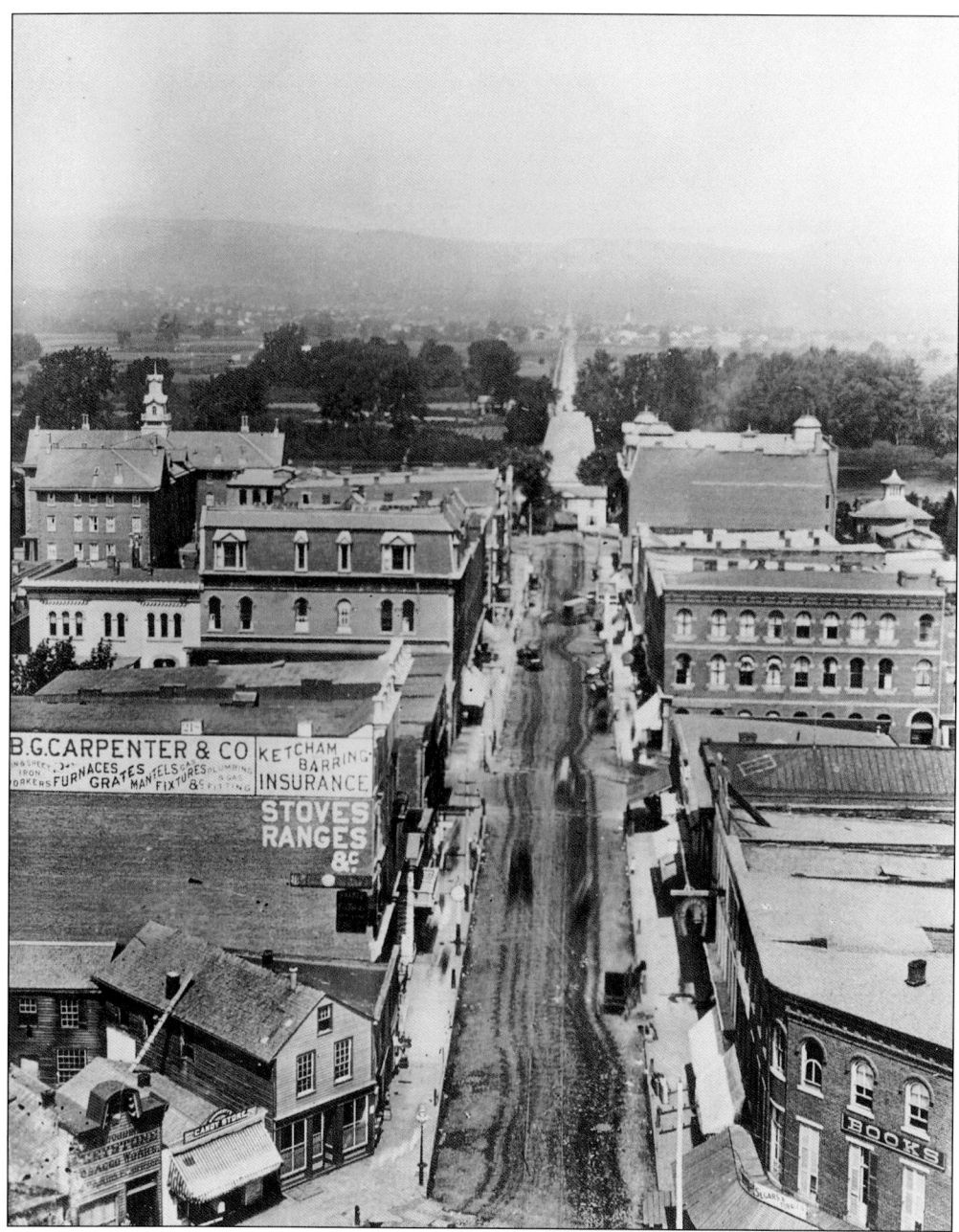

WEST MARKET STREET FROM THIRD FLOOR OF COURTHOUSE, 1890. Seen above at the end of West Market Street is the covered Market Street Bridge and the Hendrick B. Wright ticket office named for U.S. Congressman Hendrick Bradley Wright (1808–1881). The original wooden toll house was replaced with the brick ticket office in 1885. The first Market Street Bridge was constructed in December 1818, spanning the Susquehanna River connecting Wilkes-Barre and Kingston. Flooding in 1819 and a hurricane in 1824 damaged the bridge, forcing it to close. The bridge was replaced by a covered toll bridge between 1825 and 1826. The Market Street Bridge closed in January 1892, and the wooden toll bridge was replaced by a steel bridge that opened on April 16, 1892.

REYNOLDS FAMILY COTTAGE IN WEST DALLAS, 1899. This picture, taken on August 25, 1899, includes John Butler Reynolds and R. Bruce Ricketts (1839–1918), who owned timberland in Columbia, Luzerne, and Sullivan Counties. During the Civil War, Colonel Ricketts served in the 43rd Regiment Pennsylvania Volunteers and commanded Battery F, which defended Cemetery Hill during the Battle of Gettysburg. In 1868, R. Bruce Ricketts married Elizabeth Reynolds.

CANAL STREET IN WILKES-BARRE, C. 1880. Seen above, canal boats are being built in the center, and the Conyngham and Paine Central Store is on the right. The Wyoming Division of the North Branch Canal of the Pennsylvania canal system was under construction from 1828 to 1834. The canal was completed between Northumberland and Pittston in 1834, and it was used to transport coal, lumber, and building supplies. Canal transportation remained in operation until 1881.

MAIN STREET IN EDWARDSVILLE, 1900. This photograph was taken near the intersection of Green Avenue (now Green Street) in Edwardsville. Note the trolley tracks in the middle of unpaved Main Street. Edwardsville borough was incorporated in 1884. Between 1900 and 1910, the borough population increased from 5,165 to 8,407, and more than 65 percent of Edwardsville residents were from Wales or were of Welsh descent.

PIONEER VOLUNTEER FIRE COMPANY NO. 1 IN HAZLETON, 1900. The fire chief is seen in the center of this image. Hazleton borough was incorporated on January 5, 1857. Civil War veterans organized the borough's first fire company in 1866. The Grand Army of the Republic (GAR) Robinson Post No. 20 in Hazleton was founded on December 26, 1866. Pioneer No. 1 Volunteer Fire Company was established on April 9, 1869. The Hazleton's South Side Station opened in May 2005 and currently houses the Pioneer No. 1, East End No. 3, and Heights No. 4 fire companies.

VIEW OF PLYMOUTH, 1902. Pictured above are debris piles, coal breakers, schools, and company houses. Plymouth Township was established by the Susquehanna Company in 1769. In 1807, Abijah Smith was the first to open a mine and ship coal from Plymouth. Plymouth borough was incorporated in 1866. Plymouth grew rapidly during the coal industry's boom years. In 1910, the population of Plymouth reached its peak at 16,996. In addition to mining coal, Plymouth was known for producing mine drilling machines, miners' squibs, silk, and lumber.

WELCOMING HOME SOLDIERS AT PUBLIC SQUARE, 1919. In this image, Wilkes-Barre is decorated for soldiers returning from World War I. Advertisements for the Savoy Theatre and Wilkes-Barre Business College, as well as the buildings of Wilkes-Barre City Hall, Hotel Redington, Savoy Theatre, First National Bank, and the Welles Building are visible. John A. Redington operated the Hotel Redington, later owned by Conrad F. Goeringer and the Genetti family.

EAST MARKET STREET FROM PUBLIC SQUARE, 1913. This photograph was taken on April 10, 1913. On the right were the Jonas Long's and Sons Department Store, Savoy Theatre, and the First National Bank of Wilkes-Barre. Note the Ganoga Ice Company delivery wagon in front of the E. W. Clothing Company next to East Market Street. Ganoga Lake in Sullivan County was part of Robert Bruce Ricketts' extensive land holdings. The Ganoga Lake Ice Company was incorporated in 1897, and it was in operation until 1915.

NORTH MAIN STREET AND BUILDINGS SEEN FROM PUBLIC SQUARE, 1913. The image above was taken at the same time as the preceding photograph, dated April 10, 1913. The Lewis and Bennett Hardware Store was across North Main Street from the Myers Exchange and Banking House. To the right of North Main Street, behind the Wilkes-Barre Railway Trolley No. 262, are the Western Union Telegraph and Cable Office, Rhenard's Studio, Pustin Telegraph and Cable Company, Portrait Studio, John Shultz Tailor, and Adam Turke's store in Munro's Hall.

WILKES-BARRE FIRE DEPARTMENT NO. 2, 1910. A group of firemen, including Samuel W. Bartleson, pose on a fire company truck in front of the A. C. Laning and W. J. Harvey building. Matthias Hollenback's grandson Augustus C. Laning (1808–1875) built a stone building and iron foundry on Public Square in 1832. William J. Harvey of Plymouth, born in 1837, worked with his father, H. H. Harvey, in coal mining operations and invested in real estate development.

EDWARDSVILLE FIRE DEPARTMENT ON TRUCK NO. 2 ON MAIN STREET, 1920. In 1898, the Bartels Brewing Company was founded in Edwardsville and operated on the corner of Russell and Plymouth Street. The company was known for their lager, ale, porter, and the $5,000 beer. The Lions Brewery in Wilkes-Barre acquired the Bartels Brewing Company in 1968.

GAR Conyngham Post No. 97 Memorial Hall in Wilkes-Barre, c. 1965. The Grand Army of the Republic was founded by Civil War veterans in 1866 as the first integrated national organization. It reached its largest enrollment of 490,000 members in 1890. There were 640 GAR posts in Pennsylvania. Conyngham Post No. 97 was founded on April 10, 1880, named for Col. John Butler Conyngham (1827–1871). Charles Benjamin Johnson was commander of GAR Conyngham Post No. 97 when the building on 146 South Main Street was dedicated on April 9, 1890. After Conyngham Post No. 97 disbanded, the former GAR building was sold in 1941. It was used for organizations including the Sons of Union Veterans of the Civil War and the AFL-CIO Union. The two life-size statues framing the entrance were relocated to the Kingston Armory, and the former GAR building was demolished after this photograph was taken. The last GAR member in Luzerne County was Alfred W. Gabrio (1846–1946) of Hazleton.

WILLIAM LORD CONYNGHAM, 1880. Wilkes-Barre coal broker and cofounder of the firm of Parrish and Conyngham, and the Conyngham and Paine Central Store, William Lord Conyngham partnered with Joseph Stickney, whose company supplied anthracite coal to Illinois, Maryland, Massachusetts, Missouri, New York, and Pennsylvania. In 1881, Conyngham purchased 100 acres from Joseph Harter of Trucksville, forming the foundation of the agricultural and summer estate of Hillside Farms. Hillside Farms grew into a 400-acre farm raising Clydesdale and Belgian draft horses, Dorset sheep, Berkshire hogs, and dairy herds of registered Holstein-Friesian, milking shorthorns, and Jersey cattle. In 2005, the Lands at Hillside Farms was created as an agricultural center and educational resource to preserve Hillside Farms. (Courtesy the Lands at Hillside Farms.)

LVRR STATION IN DALLAS, C. 1900. Pictured above is the Lehigh Valley Railroad passenger depot and freight station with the Raub's Hotel in the background. Raub's Hotel, built by Albert S. Orr in 1858 at the confluence of Church Street and Lake Street in Dallas, was operated by Philip T. Raub. Dallas borough was incorporated on April 21, 1879, from Dallas Township, named for Alexander J. Dallas (1759–1817), the father of George M. Dallas (1792–1864).

WESTMORELAND CLUB, 1980. Located in the former residence of Dr. Levi P. Shoemaker on South Franklin Street in Wilkes-Barre, the Westmoreland Club has been comprised of Northeastern Pennsylvania's leaders in the arts, business, education, government, and industry since the club was founded in 1873 as the Malt Club. The Westmoreland Club was incorporated on February 9, 1889. The club moved to its current location in 1922 to accommodate growing membership.

Two

EDUCATION AND RELIGIOUS LIFE

WYOMING SEMINARY IN KINGSTON, 1860. On September 25, 1844, seventeen men and 14 women became the first Wyoming Seminary students. The seminary is the oldest coeducational preparatory boarding school in the country. In the 1850s, the first international students came to the seminary. After the Civil War, a commercial department was added to encourage students to enter the Wyoming Valley's growing banking, industrial, manufacturing, and mining interests. Wyoming Seminary has two campuses 3 miles apart, which are the Upper School in Kingston and the Lower School in Forty Fort. The Lower School dates back to the Wilkes-Barre Academy founded in 1807.

INSIDE FORTY FORT MEETING HOUSE, 1895. One of the first Methodist preachers in the Wyoming Valley was Anning Owen (1751–1834), a survivor of the Battle of Wyoming. He organized a Methodist class meeting on Ross Hill near what became Edwardsville and Larksville. During 1806 to 1808, Joseph Hitchcock from Connecticut built the Forty Fort Meeting House. He also designed the Wilkes-Barre Meeting House, later called Old Ship Zion Church, on Public Square completed in 1812. (Courtesy Misericordia University Archives.)

FORTY FORT MEETING HOUSE, C. 1950. The 20-foot-by-35-foot Forty Fort Meeting House served early Congregationalists, Presbyterians, Methodists, and Episcopalians. Early ministers like Ard Hoyt, Cyrus Gildersleeve, Nicholas Murray, and E. Hazard Snowden delivered sermons inside this structure. In March 1860, the Pennsylvania legislature approved a bill that created the Forty Fort Cemetery Association that maintains the building and the cemetery.

Forty Fort Methodist Episcopal Church, 1925. On November 20, 1872, the Methodists formed their own independent congregation and moved to the John B. Smith Church on Slocum Street in Forty Fort soon after. In 1887, a church was built on the site of the borough park to accommodate the growing congregation. The present Forty Fort United Methodist Church, built at the intersection of Wyoming Avenue and Yeager Avenue, was dedicated on April 12, 1925.

St. James Episcopal Church in Pittston, 1900. Episcopalians worshipped in the Wilkes-Barre Meeting House on Public Square after it was completed in 1812. During a period of intense missionary work by the Episcopal Church, St. James Church was founded in Pittston in 1849. Like Pittsburgh, Pittston was named for British statesman William Pitt the Elder (1708–1778). First settled in 1770, Pittston borough was incorporated in 1856, and it was chartered as Pittston City on December 10, 1894.

45

FIRST METHODIST EPISCOPAL CHURCH IN WILKES-BARRE, 1900. Located at 45-53 North Franklin Street, the First M.E. Church was built largely through the generosity of philanthropist Priscilla Lee Bennett of Wilkes-Barre on land donated by her husband, Ziba Bennett. She commissioned architect Bruce Price (1845–1903) to build the Sunday school in 1876 and the church buildings in 1883. Bruce Price combined French Gothic and Romanesque architecture to create the church's facade. He was the father of Emily Post (1872–1960), who authored *Etiquette in Society, in Business, in Politics, and at Home* and founded the Emily Post Institute in 1946.

First Presbyterian Church in Wilkes-Barre, 1900. Located at 97 South Franklin Street, the third First Presbyterian Church was designed and built with a steel frame construction and clad in Laurel Run Redstone, also known as Mauch Chunk Shale, in 1889 by New York architect James Cleveland Cady. Cady designed the American Museum of Natural History in New York. From 1848 to 1849, the Presbyterians erected a church at 71 South Franklin Street that became the Osterhout Free Library in 1889. Merchant Isaac Smith Osterhout (1806–1882) left his estate to establish and maintain a free library in Wilkes-Barre. Melvil Dewey (1851–1931) was hired as an advisor and recommended the use of the former First Presbyterian Church as a temporary library. In 1989, the Osterhout Free Library celebrated its centennial anniversary in the former First Presbyterian Church.

St. Mary's Lithuanian Roman Catholic Church, 1902. The congregation was organized in September 1902. The first pastors were Rev. J. V. Kudirka and Rev. George V. Inczura. The congregation purchased the property for the church at 258 Zerby Avenue in Kingston that was built in 1908, and a cemetery was established on Pringle Hill. Between 1929 and 1934, the congregation had grown to over 400 families. The church was consolidated in 2009. St. Ignatius' parish had its beginnings in Edwardsville in 1883 when the first Roman Catholics held services in a school near the intersection of Main Street and Church Street where the park was later built. In 1885, St. Ignatius' parish included Roman Catholic families from Edwardsville, Kingston, Larksville, Luzerne, and part of Kingston Township. In 1921, more than 9,438 people lived in Larksville due to its proximity to the mines.

GREEK CATHOLIC CHURCH IN HAZLETON, 1900. The first Greek Catholic Church in the United States was St. Michael the Archangel Ukrainian Catholic Church in Shenandoah, Pennsylvania, built in 1884. The congregation petitioned Archbishop Sylvester Sembratovitch, Diocese of Lemberg in Lviv, Ukraine, to send a priest to the United States. In 1885, Rev. Ivan Volanski (1857–1926) became the first Greek Catholic priest in the country. He started publishing the first Ukrainian newspaper in the United States, the *Ameryka*, and created the first Greek Catholic Society in 1886. His missionary work included founding the Greek Catholic Church in Hazleton in 1887. From 1888 to 1889, Reverend Volanski founded congregations in Kingston and Olyphant, Pennsylvania; Jersey City, New Jersey; and Minneapolis, Minnesota.

WELSH CONGREGATIONAL CHURCH IN EDWARDSVILLE, 1900. Located at 688 Main Street in Edwardsville at the intersection of Church Street, the church was renamed the Dr. Edwards Memorial Congregational Church in honor of Rev. Thomas Cynonfardd Edwards (1848–1927), who served the congregation for 49 years. He was born in Glandwr, Swansea, in Wales and immigrated to America in 1870. He became the minister for the Mineral Ridge Independent Chapel in Ohio and later, the First Congregational Church in Wilkes-Barre. In 1878, Reverend Edwards started his ministry in Edwardsville, where he would remain until his death on March 13, 1927. He dedicated the Welsh Congregational Church on August 30, 1889. In 1889, the annual Edwardsville Eisteddfod features, music and poetry, began. The festival was renamed the Edwardsville Cynonfardd Eisteddfod in honor of Reverend Edwards and is the oldest continuous eisteddfod in the world.

GRACE EPISCOPAL CHURCH IN KINGSTON, 1930. Located at 30 Butler Street, Grace Church started as a missionary church of St. Stephen's Episcopal Church in Wilkes-Barre. Kingston was first settled in 1771 by the Susquehanna Company of Connecticut. With the construction of the Lackawanna and Bloomsburg Railroad, Kingston expanded. Kingston borough was incorporated on November 23, 1857. In the early 1900s, Episcopalians began meeting on the front porch of the Benjamin Dorrance residence in Kingston. The congregation became an independent parish in 1921. This photograph was taken shortly after the cornerstone of the second Grace Church was dedicated.

CHURCH CHOIR IN EDWARDSVILLE, 1922. Demetrius L. Ressetar was the choir director for the Russian Orthodox St. John the Baptist's Church. In 1910, a meeting of Orthodox Christians was held to petition Archbishop Platon for the establishment of a parish in Edwardsville. On June 5, 1910, a resolution from Archbishop Platon officially created the parish and appointed Fr. Basil Oranovsky as pastor. Bishop Alexander dedicated the cornerstone for the church at 93 Zerby Avenue on March 24, 1912, and it was completed in 1913.

WYOMING SEMINARY, CLASS OF 1921. The graduates seen above include Emily Allen, Oscar Barber, Marion Andrews, Douglas Brown, Evelyn Avery, Donald Bush, May Bartels, Raymond Chase, Arline Biesel, Donald Fairchild, Carrie Bell, Arthur Fenton, Mary Bray, John Griffith, Mary Broadt, Rolland Kapp, Ruth Brodmarkle, Benjamin Kubilius, Mildred Brown, James Law, Edith Doty, William McLean, Elizabeth Emery, John Moore, Eloise Frantz, J. Peck, Dorothy Hallstead, Ehrman Reynolds, Alice Howell, William Richards, Dorothy Klopp, William Shoemaker, Helen Kulp, W. Sloan, Beatrice Kelley, Andrew Smith, Helen Lancaster, R. Smith, Mary McConnell, Peter Stazinski, Elizabeth Mace, Harold Stegner, Helen Neely, Byron Stookey, Marion Palmer, Harold Swales, Ruth Risch, Theodore Tremayne, Evelyn Roat, Lenwood Van Orsdale, Josephine Robbins, William Walker, Mary Roy, Lindsley Washburn, Beatrice Shiflew, Jerome Wilcox, Anna Weeks, and I. Yarnall.

COLLEGE MISERICORDIA, 1921. The second Bishop of Scranton, Michael J. Hoban (1853–1926), presided over the Administration Building ground breaking in Dallas on June 3, 1921. Mother Catharine McGann (1862–1943), seated second from the right, was Academic Dean of College Misericordia from 1924–1937. The building was designed by Philadelphia architect Francis Ferdinand Durang (1884–1966), son of architect Edwin Forrest Durang. The Administration Building was dedicated on August 15, 1924.

MAY DAY AT COLLEGE MISERICORDIA, 1957. May Day was held from 1927 to 1967. Seniors would elect a May Queen who led a formal procession to crown the statute of the Blessed Virgin Mary in front of the Administration Building. Seniors wore formal gowns, and underclassmen wore academic robes. On Mercy Day, September 24, 2002, the Administration Building was rededicated as Mercy Hall, in honor of Misericordia's founders, the Religious Sisters of Mercy.

INSIDE ST. STEPHEN'S EPISCOPAL CHURCH, 1874. The first St. Stephen's Church was completed in 1822. In 1823, the church was consecrated by Bishop William White (1747–1836). Rev. Henry Lawrence Jones was rector from 1874 to 1914. The church was destroyed by fire on Christmas Day 1896. The present St. Stephen's Pro-Cathedral located at 35 South Franklin Street in Wilkes-Barre was designed in 1897 by Philadelphia architect Charles M. Burns (1838–1922) and Scottish sculptor J. Massey Rhind (1860–1936). The church reopened on Christmas Day 1897.

SHICKSHINNY SCHOOL, 1876. Mr. Mace was the teacher of the school seen here. Shickshinny borough was organized from Salem Township and Union Township on November 30, 1861. Early businesses included a flour mill started by G. W. Search and Lot Search in 1865, and blacksmith shops operated by Miner Brown and Henry Wagner. In 1865, a toll bridge to Mocanaqua was built. In 1866, Jesse Beadle, L. T. Hartman, and Frederick Beach established an iron foundry. Amos Hess built a planing mill for the growing lumber industry in 1874.

ST. THERESE'S ROMAN CATHOLIC CHURCH, C. 1990. Fr. John O'Leary was appointed pastor of the first Roman Catholic parish in the Back Mountain, Our Lady of Victory at Harvey's Lake on August 1, 1926. Saint Therese's Church in Shavertown was established as a parish on November 3, 1926, and Father O'Leary was the priest from 1926 to 1936 and 1943 to 1957. The cornerstone of St. Therese's Church was dedicated in November 1928, and the first Eucharist was held on Christmas Eve 1928. The church was dedicated in memory of Sr. Maria Francoise Therese (1873–1897), who belonged to the order of Carmel of Lisieux in France. She was canonized by Pope Pius XI on May 17, 1925.

FIRST QUEEN AT KING'S COLLEGE, 1947. Florence Matura was elected the first queen of a formal dance at King's College in Wilkes-Barre. She graduated from College Misericordia in 1947 and married Stanley Hozempa, a graduate of King's College. In 1946, the Congregation of Holy Cross from the University of Notre Dame founded King's College in Wilkes-Barre. The Congregation of Holy Cross originated in LeMans, France, in 1837. The Administration Building at King's College was originally built as the headquarters for the Lehigh Valley Coal Company in 1913.

Three

Coal Culture

Baltimore Coal Breaker Employees at the East End of Wilkes-Barre, 1854. The East End of Wilkes-Barre was first mined in 1814. In 1829, the property was sold for $35 an acre to Thomas Simington and other investors from Baltimore, Maryland. The Baltimore Coal Company was organized in 1836. The East End was the site of a gravity railroad designed by Alexander Gray to transport coal to the canal. The average wages for mine employees in 1870 were $3 for miners, $2 for laborers, and 80¢ for helpers.

VIEW OF SHICKSHINNY FROM ACROSS THE SUSQUEHANNA RIVER, 1860. In 1830, Humphrey Davenport prospected land owned by Nathan Beach and discovered coal on Rocky Mountain near Shickshinny. Initially coal was mined and brought down the mountain by teams of horses. Nathan Beach's grandson Dr. Darwin Crary invented the first inclined chute in 1840 used by the coal industry to bring coal down from the mountain to the canal.

ALEXANDER GRAY BREAKER, 1865. The breaker was located in Wilkes-Barre Township near the intersection of Coal Street and the Nanticoke Branch of the Central Railroad of New Jersey. Alexander Gray and Company built the breaker in 1860, but it was torn down in 1874. The photograph above shows mules and mine cars on an elevated railway. Alexander Gray emigrated from Scotland in 1832, and he became the second president of the First National Bank of Wilkes-Barre.

Breaker in Nanticoke, c. 1880. Canal boats were used to transport coal from the Susquehanna Coal Company Nanticoke Breaker. The company was incorporated in April 1867 as the Pittston Railroad and Coal Company and then changed its name to the Susquehanna Coal Company in February 1869. Chutes at the bottom of the breaker were lowered to fill the canal boats with coal for market, and the water level was controlled by the Nanticoke Dam built in 1830.

SCC Breaker No. 7 in Nanticoke, 1889. Nanticoke borough was incorporated on January 31, 1874. Between 1880 and 1890, the population of Nanticoke grew from 3,884 to 10,044. On December 18, 1885, twenty-eight mine workers were killed by a flow of quicksand at Susquehanna Coal Company Slope No. 1 in Nanticoke; their bodies were never recovered. The Pennsylvania Railroad and the Pennsylvania Coal Company owned a controlling interest in SCC.

BREAKER NO. 3 IN PLYMOUTH, C. 1880. The Susquehanna Coal Company controlled approximately 5,823 acres of coalfields on both sides of the Susquehanna River at the Nanticoke Dam. In 1825, Washington Lee, the first person to mine coal in Nanticoke, became president of the Susquehanna Coal Company. As seen in this image, coal from the breaker is being loaded into canal boats, and company houses are above the breaker. Washington Lee was the grandfather of Emily Post.

MOCANAQUA BREAKER UNDER CONSTRUCTION, 1893. The breaker was operated by the West End Coal Company. The first breaker at Mocanaqua burned on March 12, 1893. This photograph was taken when the second breaker was being built on June 15, 1893. The Mocanaqua Breaker, which measured 300 feet long and 180 feet high, was capable of producing 1,000 tons of processed coal each day. The breaker was built for $50,000, and it was improved with $50,000 worth of equipment.

SHERIFF'S DEPUTIES AFTER LATTIMER MASSACRE, 1897. Pictured above are some of the Coal and Iron Police who were deputized by Luzerne County sheriff James L. Martin to subdue the strikers. The deputies opened fire on 400 unarmed strikers at the Lattimer mine near Hazleton on September 10, 1897, killing 19 men and wounding at least 39 others. Many of the victims were from Hungary, Lithuania, Poland, and Slovenia. Sheriff Martin and 73 deputies were arrested, stood trial, and were found not guilty on March 7, 1898.

NINTH PENNSYLVANIA NATIONAL GUARD OFFICERS AT THE LATTIMER RIOTS, 1897. Pictured above are, from left to right, (first row) Col. Charles Bowman Dougherty and Maj. William Sharp; (second row) Dr. Walton S. Stewart, Maj. Edmund N. Carpenter, Maj. John S. Harding, Lt. Col. McKee, and Capt. George North. The National Guard, sent to subdue the strike, withdrew on September 29, 1897. The 19 strikers killed by Sheriff Martin's deputies were Sebastian Broztowski, Mike Ceslak, ? Chrzeszeski, Adalbert Cazja, John Futa, Anthony Grekos, Steve Jurich, Andrew Jurachek, ? Kulik, Andrew Mieczkowski, ? Monikaski, Clement Platek, Ralph Rekewicz, ? Skrep, John Tarnowicz, Jacob Tomasantas, ? Zagorski, ? Ziominski, and ? Ziemba.

STATE MILITIA AT DODSON BREAKER NO. 12 IN PLYMOUTH, 1877. The Railroad Strike of 1877 began in June when the Pennsylvania Railroad cut its employees' wages by 10 percent. A general strike was called in Northeastern Pennsylvania on July 25, 1877, and mine workers in Plymouth employed by the Delaware, Lackawanna and Western Railroad went on strike. On August 2, 1877, state militia came to the Wyoming Valley to subdue the strike. Built in 1869, the Dodson Breaker was located at Bull Run in Plymouth.

STEAM SHOVEL MEN IN HAZLETON, 1900. This photograph includes members of the Union of Associated Steam Shovel Men Local No. 8 and the St. John's First Slovak Band of Hazleton. According to the American Federation of Labor in 1916, the International Brotherhood of Steam Shovel and Dredgemen had jurisdiction over unionized steam shovel operators. The Union of Associated Steam Shovel Men organized many steam shovel operators in Luzerne County.

BREAKERS IN ASHLEY, 1938. The 11-story, 134-foot Huber Breaker was built behind the Maxwell Breaker No. 20 that opened in 1895. The Central Railroad of New Jersey subsidiary, the Lehigh and Wilkes-Barre Coal Company, operated the Maxwell Breaker named for company president Roger Maxwell. The Lehigh and Wilkes-Barre Coal Company merged with the Glen Alden Coal Company. Between 1938 to 1939, the Maxwell Breaker was demolished after the completion of the Huber Breaker. Named for Glen Alden Coal Company chairman Charles F. Huber, the Huber Breaker could prepare 7,000 tons of refined coal each day.

BLACKSMITH THOMAS ASHTON SHOEING A MULE AT NOTTINGHAM SHAFT, 1900. Mules were stabled underground and often lived out their lives working in the mines. During the 1902 and 1904 floods, several hundred mine mules drowned when the mines flooded. Several mining accidents and gas explosions occurred at the Nottingham Shaft in Plymouth. Four men were killed by falling coal on June 10, 1889. Gas explosions killed many mine workers, including eight on February 1, 1890; seven on January 11, 1910; and 15 on January 15, 1947.

COUNCIL RIDGE COLLIERY IN ECKLEY, 1899. In 1854, Sharpe, Leisenring and Company, later known as Sharpe, Weiss and Company, leased land from the estate of early coal operator Tench Coxe (1755–1824) from Philadelphia. The company built the Council Ridge Colliery that consisted of three breakers and the company town of Eckley, named for Tench Coxe's grandson Eckley B. Coxe (1839–1895). Sharpe, Weiss and Company's lease ended in 1875, and the Council Ridge Colliery was later operated by the Coxe family and other companies.

SIX-TON BLOCK OF ANTHRACITE COAL, 1900. The coal was mined from Maxwell No. 20 mine in Ashley. The breaker was owned by the Lehigh and Wilkes-Barre Coal Company, later merging with the Glen Alden Coal Company, which mined and processed coal, then sold it exclusively to the DL&W Coal Mine Department, who marketed it under the trademark Blue Coal. In 1900, the average wages for mine employees were $2.25 for miners, $1.40 for laborers, and 75¢ for helpers.

Breaker Boys Playing Football at Kingston No. 4 Breaker, 1900. Before 1885, breaker boys as young as six worked 10-hour days separating coal from rock, slate, and wood. Breakers processed mined coal and separated coal by size before it was loaded into railroad cars. In 1891 and 1892, Ellen Webster Palmer (1840–1918) founded the Boys Industrial Association in Wilkes-Barre to provide educational and recreational opportunities for breaker boys. This photograph was taken at noon during an hour of recreation.

Plymouth Coal Company Breaker Boys, 1899. The Plymouth Coal Company was first managed by John J. Shonk, while John C. Haddock gained control of the Dodson Breaker in 1877. In 1882, Haddock assumed control of the Plymouth Coal Company and managed it until his death in 1914. The photograph above was taken on the same day the first Dodson Breaker caught fire, on July 13, 1899. Construction on the second Dodson Breaker began on March 5, 1900. Due to mine subsidence, Plymouth Borough obtained an injunction in 1914 that prevented the Plymouth Coal Company from mining that year.

BREAKER BOYS AT THE CHUTES WITH FOREMEN, 1900. Before child labor laws, breaker boys often dropped out of school to help support their families. This was common employment for young boys in company towns. In 1885, the State of Pennsylvania passed a law prohibiting coal companies from hiring anyone under the age of 12; however, families often forged birth certificates in order for their sons to work. After the Coal Strike of 1902, breaker boys worked nine-hour days removing debris from chutes of moving coal inside the breaker.

EXETER COLLIERY IN WEST PITTSTON, 1900. On November 5, 1898, nine mine employees were just starting their shift at the Exeter Colliery. While riding their carriage down the shaft, it collided with three fully loaded coal cars weighing 11 tons, causing it to plummet 360 feet. Michael Smith, Andrew Tinko, Michael Podesabanny, Michael Brazuke, Michael Waslowski, and Joseph Andrewoski were killed instantly; William Pullos, Joseph Winsler, and Paul Leckanodes were fatally injured.

COMPANY HOUSES IN FERN GLEN, 1900. The picture above was taken near the Deringer Colliery. One of the long-term residents of Fern Glen in Black Creek Township was Paul P. Balog (1907–1988), who worked as a miner at the Deringer Colliery until he retired. Lifelong residents of Fern Glen included Edgar Morgan (1897–1959) and his wife, Edna May Gernhardt Morgan (1899–1955). Edgar Morgan worked as a laborer at the Deringer Colliery.

NOTTINGHAM MINE SHAFT PUMP ROOM IN PLYMOUTH, 1902. This photograph includes mine employees Ben Davis and Gladstone Roberts. By 1908, the Nottingham Colliery processed coal from the Washington mine and the mines established by early coal operators Abijah Smith and his brother John. In 1807, Abijah Smith purchased a boat from John P. Arndt and transported 50 tons of coal down the Susquehanna River to Columbia in Lancaster County, Pennsylvania.

STRIP MINING OPERATION IN HAZLETON, 1900. This steam shovel, built in Erie, was operated by the Dick Construction Company of Hazleton. On November 16, 1927, one miner was killed and six men were entombed during a mining accident at Tomhicken Colliery, owned by the Lehigh Valley Coal Company near Hazleton. One of the last mining disasters in Northeastern Pennsylvania occurred on August 13, 1963, at the Sheppton Mine near Hazleton when three men were trapped in a cave in and safely rescued.

AERIAL VIEW OF HAZLETON, 1960. In 1818, Nathaniel Beach and Tench Coxe first discovered coal near Hazleton in Beaver Meadows. Company towns surrounding Hazleton included Beaver Meadows, Drifton, Eckley, Freeland, Hollywood, Jeddo, Jeansville, Junedale, McAdoo, Milnesville, Stockton, Tresckow, Weatherly, and West Hazleton. Beaver Brook Coal Company, operated by C. M. Dodson and Company, owned the small company town of Beaver Brook near Hazleton. Hazleton had grown to 14,000 people by 1891, and Hazleton City was incorporated on December 4, 1891.

SECOND NOTTINGHAM BREAKER BEING BUILT, 1904. The photograph of Nottingham Breaker in Plymouth (right) was taken on April 11, 1904. The second breaker was built next to the first breaker that was demolished in 1904. On March 21, 1865, the Nottingham Coal Company of Baltimore was incorporated and secured a lease to mine coal from the Reynolds family in Plymouth. In 1910, the second Nottingham Breaker and shaft hoisted a record 150 coal cars in one hour.

MINERS AFTER SHIFT CHANGE AT GLEN LYON BREAKER, 1910. The Susquehanna Coal Company founded the company town in 1869, and the breaker dominated the Glen Lyon landscape in Newport Township. The company's first employees were experienced Welsh miners. By 1870, the following seven major railroad companies controlled mining operations in Newport Township: the Delaware and Hudson; the Delaware, Lackawanna and Western; Illinois and Western; Lackawanna and Bloomsburg; the Lehigh Valley; Central Railroad of New Jersey; and the Pennsylvania.

ECKLEY COMPANY HOUSES AND COAL CARS, 1920. The Coxe family sold Eckley to George Huss, whose company engaged in strip mining around Eckley. In 1968, Huss leased the village of Eckley to Paramount Pictures to film *The Molly Maguires* starring Sean Connery and Richard Harris (1930–2002). The Huss Coal Company sold Eckley to the Anthracite Historical Site Museum, Inc. Eckley Miners' Village is maintained by the Pennsylvania Historical and Museum Commission.

BIRD'S-EYE VIEW OF EDWARDSVILLE, 1892. The insert above illustrates the Edwardsville Public School. In 1892, the Kingston Coal Company operated four breakers in Edwardsville, and the Delaware and Hudson Coal Company owned and operated the Boston Breaker. Visible are Center, Church, Main, Murry, Plymouth, Payne, Railroad, Short, and Slocum Streets and Hillside Avenue. Churches included the Bethesda Congregational, Christian, Emanuel Baptist, Welsh Baptist, Welsh Congregational, Methodist Episcopal, and Presbyterian.

AVONDALE COLLIERY IN PLYMOUTH, 1930. In 1811, Freeman Thomas purchased the Avondale property in Plymouth Township where he opened a coal mine. The Avondale Colliery was developed in 1867 by the Nanticoke Coal Company, a subsidiary of the Delaware, Lackawanna and Western Railroad. When this photograph was taken, the colliery was operated by the George F. Lee Coal Company. George F. Lee died in February 1946.

LOOKING SOUTH TOWARDS SHICKSHINNY ALONG THE DL&W RAILROAD, 1938. Newport Mountain, across the Susquehanna River from Shickshinny, was successfully mined for coal. The Lackawanna and Bloomsburg Railroad started providing transportation for coal companies between 1856 and 1857, and this became the Bloomsburg Branch of the DL&W in 1873. Prior to the railroad, coal was brought to market by canal boat. The Salem Coal Company was formed to mine Rocky Mountain in 1873. The company produced 65,000 tons of coal and employed 200 men and boys.

PLYMOUTH LOOKING NORTH, 1960. This photograph of the Carey Avenue Bridge across the Susquehanna River faces Main Street, also known as Route 11. The Plymouth Street Railway was incorporated on May 14, 1889, and later leased to the Wilkes-Barre and Wyoming Valley Traction Company. When the Carey Avenue Bridge was completed in 1895, the Wilkes-Barre and Wyoming Valley Traction Company built trolley tracks across the bridge that provided a more direct trolley route to Public Square in Wilkes-Barre.

AERIAL VIEW OF PLYMOUTH, 1960. The photograph above was taken looking south along Main Street and shows Plymouth High School, as well as the Bloomsburg Branch of the Delaware, Lackawanna and Western Railroad. In 1936, the Glen Alden Coal Company operated the Nottingham Breaker in Plymouth, and the breaker produced 263,836 tons of coal. In November 1936, the Glen Alden Coal Company demolished the second Nottingham Breaker. Glen Alden Coal Company sold their coal mining properties to the Moffat Coal Company in 1953.

Four

DISASTERS

SKETCH OF AVONDALE MINE DISASTER, 1869. The Avondale Mine Disaster was the most deadly mine disaster in Northeastern Pennsylvania. The Avondale mine property was leased by J. C. Phelps of Wilkes-Barre on June 13, 1863. Phelps assigned the Steuben Coal Company to the property that merged with the Nanticoke Coal and Iron Company and built the Avondale Colliery. In 1869, Avondale Colliery had nearly 200 employees. Due to poor ventilation, the coal breaker above the Steuben Shaft at the Avondale Colliery in Plymouth Township caught fire on September 6, 1869. During the massive fire, 108 mine employees were trapped underground and died; two rescuers were killed. Among the victims were five boys between the ages of 12 and 17.

ICE JAM ON THE SUSQUEHANNA RIVER IN WILKES-BARRE, 1865. This photograph of the Market Street Bridge was taken from the steeple of St. Stephen's Episcopal Church in March 1865 when the Susquehanna River rose to 34 feet. Ice jams were common along the river when spring rains combined with melting snow in March. The first recorded floods in Luzerne County occurred on March 15, 1784, and October 5, 1786.

ICE JAM ON THE MARKET STREET BRIDGE, 1875. The image above was taken from the roof of the Wyoming Valley Hotel when the Susquehanna River rose to 35.5 feet. The bridge offered two-way traffic for horse-drawn vehicles and pedestrians. The sign on the front of the covered bridge read, "Five dollars fine for riding or driving faster than a walk or carrying fire by smoking or otherwise over this bridge." Adjacent to the toll bridge entrance was the wooden tollhouse and Matthias Hollenback warehouse.

CONRAD LEE PLANING MILL IN WILKES-BARRE DESTROYED, 1890. This building was demolished by a cyclone on August 19, 1890. Conrad Lee was born in Hanover Township in 1842. He became a lumber dealer in Wilkes-Barre, a cofounder of the lumber firm of Scouton, Lee and Company, and proprietor of the Wyoming Planing Mill. After the cyclone of 1890, the Conrad Lee Lumber Company, located on North Pennsylvania Avenue in Wilkes-Barre, was rebuilt.

HILLMAN BREAKER ON NORTH CANAL STREET IN WILKES-BARRE, 1890. The breaker was destroyed by the cyclone, and it would take months to repair the damages before mine employees could resume work. The breaker, boiler houses, engine rooms, and other outbuildings were demolished. The Hillman Vein Coal Company built the breaker in 1882. After being rebuilt, the breaker and shaft were in use until August 1900.

St. Mary's Church in Wilkes-Barre after the Cyclone, 1890. By 1845, many Roman Catholics from Germany and Ireland had settled in the Wyoming Valley, and this led to the establishment of St. Mary's parish. Germans formed their own congregation in 1856. St. Nicholas Church at 226 South Washington Street was built by William Schickel and dedicated by the first Bishop of Scranton, William O'Hara (1816–1898), on January 16, 1887. The present St. Mary's Church of the Immaculate Conception, located at 134 South Washington Street, was designed by Philadelphia architect Edwin Forrest Durang (1829–1911). Built by William O'Malley of Pittston, the cornerstone for St. Mary's Church was laid in September 1870, and the church was dedicated on December 15, 1872. On August 19, 1890, the cyclone damaged the church roof and destroyed the bell tower, which was never rebuilt. St. Mary's Church was consecrated by the archbishop of Philadelphia, P. J. Ryan, in 1891.

HOUSES DAMAGED BY THE CYCLONE, 1890. The cyclone swept through Luzerne County and Columbia County on August 19, 1890. The cyclone reached Wilkes-Barre at 5:20 p.m., and it was over by 5:31 p.m., according to the Pennsylvania Railroad Telegraph Office operator J. J. Walch. In Wilkes-Barre, 14 people were killed and nearly 400 buildings were destroyed in less than 20 minutes.

CYCLONE DAMAGE IN WILKES-BARRE, 1890. Starting on South Main Street, it destroyed the LVRR watchman's house near the Vulcan Iron Works. The cyclone turned northward to Wood Street and hit Franklin, Academy, and Ross Streets. It struck the Pennsylvania Railroad roundhouse and the Hazard Wire Rope Works near Washington and Canal Streets. On Northampton Street, the cyclone turned east to the Central Railroad of New Jersey and went to North Street, hitting buildings along Canal Street before turning east toward Bowman, Scott, and Kidder Streets.

RAILROAD CLEANUP IN PLYMOUTH AFTER FLOOD, 1902. The Susquehanna River crested at 31.4 feet on March 2, 1902. The image above shows the Delaware, Lackawanna and Western Railroad and the Central Railroad of New Jersey in Plymouth. It took months to recover from the flood damage with railroads, bridges, and roads washed out, and the trolley system was paralyzed.

HOTEL STERLING DURING THE FLOOD, 1902. This photograph, taken from the Market Street Bridge on March 3, 1902, shows buildings on North River Street. Located at 47–65 West Market Street in Wilkes-Barre, the Hotel Sterling was designed by architect J. H. W. Hawkins (1855–1923), and the main hotel was built in 1897. The Hotel Sterling was completed in five stages. It was owned by Walter G. Sterling; Homer Mallow, who completed the hotel in 1936; and Andrew J. Sordoni, former state senator and founder of Sordoni Construction.

BEDFORD AND CONYNGHAM HOUSES DURING THE FLOOD, 1902. The George Reynolds Bedford house on the left and the Charles Miner Conyngham house on the right were on South River Street and West South Street in Wilkes-Barre. Eight people drowned in Wilkes-Barre during the flooding. The worst flood before 1902 was the 1865 flood that crested at 34 feet.

SOUTH RIVER STREET DURING THE FLOODING, 1902. Above is the continuation of the photograph taken from the Market Street Bridge on March 3, 1902, after the Susquehanna River crested at 31.4 feet in Wilkes-Barre. The image shows the buildings on South River Street including the Hollenback Coal Exchange Building, Wyoming Valley Hotel, and the McClintock House. In 1863, New York architects Calvert Vaux (1824–1895) and Frederick Clark Withers (1828–1901) remodeled the house of attorney Andrew Todd McClintock (1810–1892) at 44 South River Street.

HOMES FOR SALE FLOODED IN WILKES-BARRE, 1904. In this image, newly built homes and vacant building lots at Academy Street and Charles Street are flooded. The sign advertises building lots for sale, on easy terms, with 10 years to pay. The year 1904 was the most destructive flood on record until 1936 and 1972. In Bloomsburg, the river crested three times in 1904—on January 24, February 10, and March 9—reaching nearly 33 feet.

PEDESTRIANS ON MARKET STREET BRIDGE DURING ICE JAM, 1904. This photograph was taken from South River Street in front of the Wyoming Valley Hotel. Several bridges were lifted off their foundations in Luzerne County. On February 9, 1904, the ice jam on the Susquehanna River destroyed the bridge between Berwick and Nescopeck, as well as the Mifflinville Bridge.

MARKET STREET BRIDGE FROM NORTH RIVER STREET DURING FLOODING, 1904. The 1904 flood in Wilkes-Barre crested three times: 25.7 feet on February 10, 30.6 feet on March 9, and 22.9 feet on March 27. In 1908, the steel bridge was purchased by Luzerne County for $165,000 and became toll free, and the Hendrick B. Wright ticket office was demolished.

NEAR MARKET STREET IN KINGSTON DURING THE FLOOD, 1904. The photograph was taken near the Market Street Bridge in Kingston, less than a mile from Kingston Corners, which had remained largely undeveloped due to flooding. The flood waters hit West Pittston on March 9, 1904, and homes were affected as far inland as Linden Street.

EAST END DISASTER IN WILKES-BARRE, 1919. A powder explosion at 6:40 in the morning on June 5, 1919, killed 92 men and injured 60 others. It was caused by an electrical wire falling into a mine car loaded with black powder that was attached to a trainload of men being transported into Baltimore No. 2 mine of the Delaware and Hudson Coal Company. The photograph was taken after the bodies of the victims were removed from the mine cars that carried their personal belongings to the surface.

BALTIMORE NO. 2 MINE AT THE EAST END DISASTER, 1919. Mounted Coal and Iron Police and the families of the victims gathered on the bridge in front of the entrance to Delaware and Hudson Coal Company Tunnel No. 5 as rescue crews brought victims and injured men to the surface following the East End Disaster in Wilkes-Barre. The explosion happened during a shift change when 200 mine employees were entering the mines.

ST. MARY'S POLISH CATHOLIC CHURCH FUNERAL AFTER EAST END DISASTER, 1919. This mass funeral on June 8, 1919, was presided over by Rev. T. A. Klonowski, pastor of St. Mary's Polish Catholic Church in Wilkes-Barre. War hero Chuck Conners and former New York State league baseball pitcher John McCloskey were among the victims. The East End Disaster at the Baltimore No. 2 mine was the worst mining accident since the Avondale Colliery explosion in 1869.

FLOODING NEAR MARKET STREET BRIDGE IN KINGSTON ON MARCH 20, 1936. The Susquehanna River crested at 33 feet. The fourth Market Street Bridge was completed in 1929. The 1,400-foot bridge was designed by the New York architectural firm Carrére and Hastings. In the background was the Kingston Armory, home of the 109th Field Artillery Regiment.

BOYD'S RESTAURANT ON MAIN STREET IN KINGSTON DURING THE FLOOD, 1936. The Wyoming Valley was unprepared for the flood on St. Patrick's Day 1936. After the 1936 flood, federal funding led to the construction of a levee system that could withstand flooding up to 36 feet. The levees successfully held back the Susquehanna River during floods in 1946, 1955, and 1964.

HOMES ON WEST 8TH STREET IN WYOMING DESTROYED BY MINE SUBSIDENCE, 1897. This devastating sight was an ever-present threat as mine tunnels spread throughout the Wyoming Valley. Mine subsidence often occurred when supporting timbers in mines collapsed or when mining operations came too close to the surface. By 2009, it was estimated that mine subsidence in the county had cost more than $35 million in property damage.

KNOX MINE DISASTER, 1959. The Susquehanna River flooded into the River Slope Mine owned by the Knox Coal Company on January 22, 1959. The mining operation dug too close to the riverbed at Port Griffith in Jenkins Township. Pictured above are LVRR cars filled with sediment being dumped into the whirlpool in an attempt to stop the flooding. The bodies of Samuel Altieri, John Baloga, Benjamin Boyer, Francis Burns, Charles Featherman, Joseph Gizenski, Dominick Kaveliskie, Eugene Ostroski, Frank Orlowski, William Sinclair, Daniel Stefanides, and Herman Zelonis were never recovered.

MARKET STREET BRIDGE IN WILKES-BARRE DURING THE 1972 AGNES FLOOD. Volunteers are sandbagging the Market Street Bridge across from the Hotel Sterling on June 23, 1972. The levee system, in place after the 1936 flood, was reinforced with 530,000 sandbags to protect against the flood waters of Hurricane Agnes in 1972. But the Susquehanna River crested 4 feet above the levees. After the flooding, the levee system was raised to 41 feet, and it has successfully repelled less destructive floods in 1996, 2004, and 2006.

EVACUATION DURING THE AGNES FLOOD IN DALLAS, 1972. Above, a U.S. Army helicopter is landing at College Misericordia, which served as an emergency evacuation center for the Wyoming Valley in June and July 1972. More than 1,500 people were evacuated to the college campus. Emergency medical services at Nesbitt Hospital on Wyoming Avenue in Kingston were relocated to the basement of Alumnae Hall at College Misericordia.

Five

ENTERTAINMENT AND SOCIAL ORGANIZATIONS

WILKES-BARRE BICYCLE CLUB AT THE CONYNGHAM HOUSE, 1890. Before this house was built on West South Street by architect Isaac G. Perry, the property was a depot for the Lehigh and Susquehanna Railroad. The Conyngham House was later used as an art gallery before it was demolished. On the same location, Wilkes College constructed two buildings, completed in 1965 and 1969. After the death of board of trustee member and longtime benefactor Dorothy Dickson Darte in 1969, the complex was named the Dorothy Dickson Darte Center for the Performing Arts. Wilkes College was founded as Bucknell University Junior College on September 14, 1933. It became Wilkes College in 1947 and achieved university status in 1980.

HARVEY'S LAKE PAVILION, 1897. Benjamin Harvey discovered Pennsylvania's largest natural lake in 1781. Between the 1870s and 1900s, Harvey's Lake became a resort community with trains, trolleys, and a fleet of steamboats operated by the Lake Transit Company that shuttled guests to the different attractions around the lake. Hotels on Harvey's Lake included the Rhoads Hotel and the Hotel Oneonta.

WYOMING CAMPGROUND ON ASBURY AVENUE, 1895. The campground offered cabin rentals, hiking, swimming, picnic tables, and social events. The sign on the center tree read, "Smoking is prohibited in the Auditorium Park." Local picnic grounds that became amusement parks included Fern Brook Park, Hanson's Amusement Park, Rocky Glen Park, and Sans Souci Park.

WILKES-BARRE WHEELMEN CLUB AT BEAR CREEK, 1896. Club members with bicycles in the tree include club captain George Piefer (1), B. Frank Brown (2), Burt Downing (3), photographer Erskine L. Solomon (4), William Cray (5), Uranus N. Perry (6), Oscar Sim (7), Felix Constine (8), Harry Garrison (9), Daniel Lynch (10), and Wilson H. Rothermel (11). This image was used on the cover of the sheet music for "March up a Tree," composed by Wilkes-Barre musician James I. Alexander.

TROLLEY NO. 778 AT FERN BROOK PARK IN DALLAS, 1939. The photograph above was taken shortly before trolley service to Dallas was discontinued on April 30, 1939. The trolley was ordered from the J. G. Brill Company for the Eastern Pennsylvania Railway on April 2, 1924. In 1933, the trolley was purchased secondhand by the Wilkes-Barre Railway. Trolley No. 778 was scrapped in March 1948.

WILKES-BARRE WHEELMEN CLUB AT HILLSIDE FARMS, 1898. Club photographer Erskine L. Solomon took the photograph along Hillside Road in Trucksville on Sunday, April 10, 1898. In 1881, Hillside Farms began as a summer estate for the family of William Lord Conyngham from Wilkes-Barre. Construction began on Hillside Cottage in 1882. The development of Hillside Farms as a commercial dairy began in 1900.

BASEBALL GAME ON WELSH HILL IN PLYMOUTH, 1902. By the 1830s, Henderson Gaylord, whose mine was at the base of Welsh Hill in Plymouth, had built a gravity railroad that ran coal cars along Walnut Street. The cars headed down what is now Gaylord Avenue to Gaylord's wharf, where coal was loaded onto canal boats along the Susquehanna River. Early coal operators in Plymouth such as John Smith, Freeman Thomas, and Henderson Gaylord took advantage of the canal system.

BOXING CLASS IN EDWARDSVILLE, 1900. Edwardsville was named for Daniel Edwards (1825–1901), who was born in Groeswen, Glamorganshire, in Wales and came to the United States in 1858. Edwards worked as a manager of iron mines in Danville and became the superintendent of the locally owned Kingston Coal Company in 1868. Edwards became Kingston Coal Company president in 1876, a position he held until his death. In 1896, Edwards, along with others, organized the Kingston Bank and Trust Company.

St. John's Primitive Methodist Church Baseball Team, 1900. In 1888, Tamaqua resident Chris Fulmer invented the baseball catcher's mitt while playing for the minor league Baltimore Orioles. The Wyoming District of the Primitive Methodist Church included churches in Avoca, Bear Creek, Blakely, Dickson City, Hazleton, Jermyn, Laurel Run, Nanticoke, Parsons, Plymouth, and Taylor. Primitive Methodism originated in England, and the American Primitive Methodist Church was established on September 16, 1840.

Accident during the Giant's Despair Hillclimb, 1907. The crowd gathered around Louis Chevrolet's overturned Buick during the second annual race on May 30, 1907. The first race, called the Wilkes-Barre Mountain Automobile Hill Climbing Contest, coincided with the Wilkes-Barre Centennial. The race was won in two minutes and 11 seconds on May 10, 1906. The Giant's Despair Hillclimb, held in Laurel Run borough on East Northampton Street, is the oldest continuous motorsport in Pennsylvania. The Giant's Despair Hillclimb runs one mile rising 650 feet with six turns, including the Devil's Elbow.

Irem Temple at 52 North Franklin Street in Wilkes-Barre, 1909. In 1895, Irem Temple became the 71st Shrine Temple chartered by the Imperial Council of the Ancient Arabic Order of Nobles of the Mystic Shrine. The first potentate was J. Ridgeway Wright. Irem Temple was designed in the Moorish Revival style by the Wilkes-Barre architectural firm of Frederick L. Olds and Francis Willard Puckey (1874–1954). The ground breaking took place on September 21, 1907, and the cornerstone was laid during a ceremony on November 27, 1907. The three-story building was modeled after St. Sophia's Mosque in Constantinople. Irem Temple was dedicated during a two-day event on December 15 and 16, 1908. Irem Temple was sold to the Greater Wilkes-Barre Development Corporation in 2005.

CARS RACING IN THE GIANT'S DESPAIR HILLCLIMB, 1911. Early drivers included Ralph DePalma (1882–1956); Louis Chevrolet (1878–1941), who drove for Buick; and automobile manufacturer Charles W. Matheson. On May 30, 1907, H. N. Harding raced in a Matheson 60 horsepower four cylinder. Guy Reynolds was in a Matheson car during the 1908 race. In 1910, twenty-two-year-old driver J. W. Parkin Jr. raced in a new Matheson Light Six.

SKEE BALL ALLEY AT HARVEY'S LAKE, 1915. The prize for the highest score of the day was $1. A Gillette razor was the prize for the highest score of the week. The prize of $100 in gold was for a perfect score of 450. The first bowling alley at Harvey's Lake, adjacent to the Rhoads Hotel, was built in 1905 by John Butler Reynolds, Clinton Honeywell, and A. A. Holbrook.

POLISH FALCONS BAND AT ST. STANISLAUS CHURCH IN NANTICOKE, 1918. Many Polish-American organizations were founded in the Wyoming Valley, and one of the oldest Polish Roman Catholic parishes was St. Stanislaus, Bishop and Martyr, established in 1875. In 2000, the parish celebrated its 125th anniversary and supported a congregation of 1,000. The church was consolidated after its final Mass on June 3, 2010. St. Stanislaus Church was located at 38 West Church Street in Nanticoke.

BOY SCOUT TROOP NO. 2 IN EDWARDSVILLE, 1920. Lord Robert Baden-Powell (1857–1941) founded Boy Scouting in 1910. Arthur R. Eldred (1895–1951) of New York became the first Eagle Scout in 1912. Troop No. 2 enrolled 13 scouts on January 6, 1916. Wilkes-Barre Council No. 542 was chartered in 1915, and it became the Wyoming Valley Council in 1925. Hazleton Council No. 514 was chartered in 1921, and it became the Anthracite Council in 1927.

KNIGHTS OF LITHUANIA BASEBALL CLUB, 1930. This photograph was taken in West Hazleton on July 13, 1930. Ethnic organizations such as the Knights of Lithuania were organized by Roman Catholic Churches to preserve national identity, culture, and traditional customs. The Knights of Lithuania was founded as a youth organization on April 27, 1913.

DANCE HALL DEMOLISHED AT FERN BROOK PARK, 1948. Fern Brook Park was built on the site of Offset Paperback in Dallas. After the Starlight dance hall opened in 1926, many celebrities performed there, including Eubie Blake (1883–1983), Cab Calloway (1907–1994), Duke Ellington (1899–1974), and Rudy Vallee (1901–1986). The dance hall was later used as a skating rink.

COMERFORD THEATRE IN WILKES-BARRE, 1938. The art deco theatre opened, showing *Alexander's Rag Time Band* starring Tyrone Power (1914–1958), Don Ameche (1908–1993), and Alice Faye (1915–1998) on August 18, 1938. Tickets were 50¢. In 1937, the site on Public Square was chosen by the movie chain founded by Michael E. Comerford. In 1949, ownership was transferred to the Penn Paramount Company, and the theatre became the Paramount. It was forced to close after the 1972 Agnes Flood. In 1981, the building was placed on the National Register of Historical Places. Local business owners and civic leaders Albert Boscov, August L. Simms, and F. M. Kirby II, through the Kirby Foundation, restored the building, and it became the F. M. Kirby Center for the Performing Arts, located at 71 Public Square.

WINTERSTEEN CAROUSEL AT HARVEY'S LAKE, 1915. This carousel, built in 1909, was decorated with 44 hand-carved and painted wood animals made by Charles Looff, Solomon Stein, Harry Goldstein, and Charles Carmel. In 1914–1915, Alfred Wintersteen purchased the carousel from the W. F. Mangels Carousel Works of Coney Island, New York. The carousel was leased to the park at Harvey's Lake that became Hanson's Amusement Park until it closed in 1984.

KINGSTON FIRE DEPARTMENT SPONSORED THE FIREMEN'S BAZAAR IN PLYMOUTH, 1902. The sign above the lemonade stand in the center reads, "Lemonade made from Highland Mineral Water presented by Phil Raub." Philip T. Raub was the proprietor of the Raub's Hotel in Dallas until he sold the hotel to E. G. Stevens. In 1922, businessman Philip T. Raub died at the age of 74.

IREM TEMPLE COUNTRY CLUB IN DALLAS, 1950. In 1920, Shriner Leo W. Long considered the initial purchase of a country club for Irem Temple. The Derr Estate and adjoining Watkins Farm were purchased in Dallas Township for $53,500. On December 20, 1922, at the annual meeting of the Irem Temple in Wilkes-Barre, the purchase of the property for the future site of the Irem Temple Country Club in Dallas was announced.

COUNTRY CLUB ROAD IN DALLAS, 1950. The Irem Temple Country Club was dedicated on August 1, 1923. The club pavilion, constructed at a cost of $40,235, opened on May 23, 1925. The golfer locker house cost $75,270 to build. In 2009, the new 26,868-square-foot Irem Shrine Center and Clubhouse replaced the original clubhouse located at 397 Country Club Road in Dallas.

GIANT'S DESPAIR HILLCLIMB CARS BEING INSPECTED, 1956. Sports cars lined up in the parking lot across Market Street from the Hotel Sterling in Wilkes-Barre before the race during the weekend of July 22 and 23, 1956. The parking lot at the intersection of West Market Street and South River Street was the site of the Hollenback Coal Exchange Building, demolished in 1937.

GIANT'S DESPAIR WHEEL CLUB IN DALLAS, 1956. Some of the most famous drivers to race the Giant's Despair Hillclimb included Carroll Shelby, Roger Penske, and Oscar Koveleski. Carroll Shelby, driving a Ferrari, became the first driver to break the one-minute barrier before retiring from racing in 1959. In 2007, Darryl Darko won the Giant's Despair Hillclimb in 38.36 seconds.

Six

Government and Military Service

Veteran Elisha Blackman, c. 1845. Elisha Blackman (1760–1845) was born in Lebanon, Connecticut, and his family came to Wilkes-Barre in 1772. On July 3, 1778, Pvt. Elisha Blackman fought in the Battle of Wyoming as a member of Captain Bidlack's company, and he escaped the Wyoming Massacre by swimming to Monoconock Island. During the battle, Blackman's father served as an ensign in the 2nd Alarm Company. His brother-in-law Darius Spafford was killed during the fighting. The Blackman family returned to Connecticut, but Elisha Blackman returned to Wilkes-Barre with Captain Spalding's Company in August 1778. Blackman joined the Continental Army but later returned to Connecticut to become a tanner. In 1786, Blackman returned to Wilkes-Barre and built a log cabin on the site of his father's old farm near Main Street below Academy Street. He married Anna Hurlbut (1762–1828), and they raised six children. In 1791, the Blackman family moved to a farm in Hanover Township. In 1835, Blackman started receiving a veteran's pension from the U.S. government.

SECOND LUZERNE COUNTY COURTHOUSE, C. 1855. In 1791, a log structure was built in Wilkes-Barre and served as the first Luzerne County Courthouse and jail. The second courthouse was constructed in the Georgian style from 1801 to 1804. A separate jail was built on Market Street in 1802. On April 25, 1806, Judge Jesse Fell issued a public statement calling for a meeting at the courthouse on May 6 to vote for council members, a constable, and burgess for Wilkes-Barre. Fell was elected burgess of Wilkes-Barre and Lord Butler became council president.

THE COMPANY D, 149TH REGIMENT, 1864. This photograph was taken during the siege of Petersburg, Virginia, on November 6, 1864. The 149th Pennsylvania Volunteers Infantry Regiment was comprised of soldiers from Alleghany, Clarion, Clearfield, Huntingdon, Lebanon, Luzerne, Lycoming, Mifflin, Potter, and Tioga Counties. Company D was mustered into service in Luzerne County, and it was commanded by Maj. James Glenn, Maj. Jacob Slagle, Capt. W. M. Dailiesh, and Lt. John A. Snodgrass. The regiment was mustered out of service on June 24, 1865.

JUDGE JOHN NESBITT CONYNGHAM (1798–1871). John Nesbitt Conyngham married Ruth Ann Butler (1801–1879), the granddaughter of Zebulon Butler. Their children included John Butler Conyngham, William Lord Conyngham, and Charles Miner Conyngham (1840–1894). John Nesbitt Conyngham was appointed president judge of Luzerne County Court of Common Pleas by Gov. David Rittenhouse Porter in 1841. During the Civil War, Judge Conyngham's son Col. John Butler Conyngham served in the 52nd Pennsylvania Volunteers. While stationed at Fort Clark, Texas, in 1871, Colonel Conyngham suffered from apoplexy followed by Bright's kidney disease. Upon hearing of his son's illness, Judge Conyngham set out to bring his son home to Wilkes-Barre. Tragically during his trip, Judge Conyngham was killed by a runaway railroad car in Magnolia, Mississippi, on February 24, 1871. John Butler Conyngham lived to reach Wilkes-Barre, where he died on May 28, 1871. Both are buried in Hollenback Cemetery.

PRESIDENT HAYES AT THE WYOMING MONUMENT, 1878. Pres. Rutherford B. Hayes (1822–1893) dedicated the Wyoming Monument during the centennial of the Battle of Wyoming and the Wyoming Massacre on July 3, 1878. He proclaimed, "This monument commemorative of these events and in memory of the actors in them, has been erected over the bones of the slain by their descendants and others who gratefully appreciated the services and sacrifices of their patriot ancestors." Seated in the first row are, from left to right, E. W. Sturdevant, President Hayes, U.S. Secretary of the Treasury John Sherman (1823–1900), and U.S. Attorney General Charles Devens (1820–1891). Standing in the background are U.S. Congressman Hendrick Bradley Wright, Asa Packer, former Wilkes-Barre mayor W. W. Loomis, Judge Garrick M. Harding, Payne Pettibone, Thomas Atherton, and future Pennsylvania attorney general Henry W. Palmer (1839–1913). Hendrick B. Wright was appointed district attorney of Luzerne County in 1834, founded the Wilkes-Barre Law and Library Association in 1850, and served in the U.S. House of Representatives from 1853 to 1855, 1861 to 1863, and 1877 until 1881.

WYOMING MONUMENT, 1878. This monument is decorated for the centennial on July 3, 1878. The Wyoming Commemorative Association, founded in 1878, continues the annual commemoration each July 3rd with speakers, including Pres. Rutherford B. Hayes in 1878, Dr. William Elliot Griffis (1843–1928) in 1903, the Honorable Simeon Eben Baldwin (1840–1927) in 1907, former Pennsylvania governor Arthur James (1883–1973) in 1947, the Honorable William Scranton in 1961, U.S. Senator Hugh Scott (1900–1994) in 1969, U.S. Congressman Daniel J. Flood (1903–1990) in 1973, and Tweed Roosevelt in 2005.

THIRD LUZERNE COUNTY COURTHOUSE, c. 1900. This was the final courthouse built on Public Square. The courthouse was designed by New York architect Joseph C. Wells, and the cornerstone was laid with Masonic ceremonies on August 12, 1856. In 1875, architect Bruce Price was commissioned to build a third floor on the courthouse. In January 1894, it was decided that the courthouse did not have enough space to conduct public business. After the present courthouse was completed on the River Common in 1909, the old courthouse was demolished.

SOLDIERS LEAVING THE LVRR STATION IN HAZLETON FOR FORT MEADE, 1917. During World War I, the 109th Field Artillery Regiment was commanded by Col. Asher Miner as part of the 28th Infantry Division in France. In 1907, the Lehigh Valley Railroad Station was built at a cost of $95,000. LVRR passenger service was discontinued on February 4, 1961. The LVRR Station in Hazleton was demolished in 1963.

WILKES-BARRE PARADE FOR RETURNING 109TH FIELD ARTILLERY, MAY 19, 1919. The 1st Battalion 109th Field Artillery is one of the oldest units in the U.S. Armed Services. It was organized under Col. Zebulon Butler in the Wyoming Valley on October 17, 1775, as the 24th Regiment of the Connecticut Militia. It is the only unit in the United States authorized to carry two state flags: Pennsylvania and Connecticut. The 109th Field Artillery was assigned horse-drawn 75 mm howitzers on October 11, 1917.

Fourth Luzerne County Courthouse under Construction, c. 1907. Pittsburgh architect Frederick J. Osterling (1865–1934) originally designed the courthouse to be erected on Public Square, but plans were changed to accommodate the building on the River Common. Wilkes-Barre architects Frederick McCormick and Harry Livingston French (1871–1928) were commissioned to design the interior and rotunda on January 17, 1906. The present Luzerne County Courthouse, located at 200 North River Street in Wilkes-Barre, was completed in 1909 at a total cost of $2 million.

Civil War Veterans in Edwardsville for Decoration Day, 1880. Luzerne County was home to several Civil War Congressional Medal of Honor recipients, including Lt. Col. Eugene B. Beaumont (1837–1916), Cavalry Corps; Pvt. Theodore L. Kramer (1847–1910), 188th Pennsylvania Infantry Company G; Sgt. Sylvester D. Rhodes (1842–1904), 61st Pennsylvania Infantry Company D; Lt. Patrick DeLacey (1835–1915), 143rd Pennsylvania Infantry Company A; and Sgt. James May Rutter (1841–1907), 143rd Pennsylvania Infantry Company C.

CIVIL WAR VETERAN STEPHEN GREGORY, C. 1865. In 1864, fifteen-year-old Stephen Gregory (1849–1935) enlisted with Company B of the 58th Pennsylvania Volunteers Infantry Regiment. He was transported with other recruits to Petersburg, Virginia, during the 292-day seige. Gregory was discharged from the U.S. Army on June 12, 1865. Other Pennsylvania regiments that came from Luzerne County during the Civil War include Companies B-H, 8th Regiment; Company K, 25th Regiment; Company I, 50th Regiment; Company K, 52nd Regiment; Company K, 81st Regiment; Company E, 96th Regiment; Company C and 11th Cavalry, 108th Regiment; Company K, 173rd Regiment; and Company K, 194th Regiment.

CIVIL WAR VETERANS FROM GRAND ARMY OF THE REPUBLIC (GAR) CONYNGHAM POST NO. 97, 1925. Pictured are, from left to right, (first row) W. S. Ramsey, J. Batt, Lorenzo Whitney, A. H. Brown, J. A. Baker, and L. G. Wilboner; (second row) George Detrick, S. J. Patterson, J. A. Opp, and P. F. Welteroth; (third row) W. H. Swainback, John Gagin, P. M. Maxfield, H. E. Ibach, and Lewis Wagner.

U.S.S. WILKES-BARRE, 1944. The 10,160-ton Cleveland Class cruiser CL-103 was launched on December 24, 1943, and commissioned on July 1, 1944. The ship took part in bombardments in French Indochina; China; and Iwo Jima and Okinawa, Japan. At Okinawa, the U.S.S. Wilkes-Barre aided the damaged carrier U.S.S. Bunker Hill. During the Japanese surrender, the cruiser entered Tokyo Bay to cover the landing of American forces. The vessel was decommissioned on October 9, 1947.

CIVIL WAR VETERAN ALONZO WHITNEY, 1931. Alonzo Whitney was the last commander of the GAR Conyngham Post No. 97 in Wilkes-Barre, which had 11 members in 1931. The post disbanded in 1934 when there were only five living members. There were 16 additional GAR posts active in Luzerne County, including No. 20 Robinson in Hazleton; No. 109 Captain Asher Gaylord in Plymouth; No. 113 Captain D. J. Taylor in White Haven; No. 147 Major C. B. Coxe in Freeland; No. 161 Lape in Nanticoke; No. 186 Wilcox in Plains; No. 213 J. Stewart Robinson in Huntington Mills; No. 245 W. G. Nugent in Pittston; No. 257 Lieutenant C. B. Post in Shickshinny; No. 283 N. T. Pennington in Fairmount; No. 339 Captain John J. Whitney in Dallas; No. 444 Keith in Wilkes-Barre; No. 499 George F. Moore in Sweet Valley; No. 563 Lieutenant Solomon Stair in Conyngham; No. 567 Lieutenant Charles H. Riley in Wyoming; and No. 598 E. L. Dana in West Nanticoke.

Seven
TRANSPORTATION

STEAMBOAT WYOMING, 1849. The *Wyoming* was one of the first steamers on the Susquehanna River launched from Tunkhannock. The first steamboat to reach Wilkes-Barre was the *Codorus* on April 12, 1826. It began offering service between Tunkhannock and Wilkes-Barre on November 8, 1849. The fare was $1, and Capt. George Converse piloted the steamboat. The *Tunkhannock*, another steamboat launched on the Susquehanna River in 1849, made regularly scheduled trips to Pittston and Towanda. The steamboat *Tunkhannock*, which cost $6,000 to build, measured 128 feet long and 22 feet wide with a 110 foot keel.

SECOND MARKET STREET BRIDGE, 1869. This photograph of the snow-covered Susquehanna River was taken from the Kingston flats while facing the direction of Wilkes-Barre. At the time, the most prominent building on South River Street was the Wyoming Valley Hotel. To the left of the Wyoming Valley Hotel is the Hollenback House, built by Matthias Hollenback in 1817 and 1818. John Welles Hollenback lived there when this image was captured.

STEAMBOAT MAYFLOWER OF PLYMOUTH APPROACHING WILKES-BARRE, 1880. The cabin of the *Mayflower of Plymouth* was decorated with oak and walnut paneling and carpeted floors. Early steamboat operators decided that the river was too shallow for long distance commercial steamboat transportation, so the vessels strictly traveled between Wilkes-Barre and the Wyoming Valley to Tunkhannock. The *Mayflower of Plymouth* sank in 1894.

THE WILKES-BARRE AT THE WYOMING VALLEY HOTEL, C. 1880. The photograph was taken as the steamboat *Wilkes-Barre* landed at the base of the Wyoming Valley Hotel on South River Street in Wilkes-Barre. The photograph was taken by steamboat captain Joel Walp (1846–1932) of Kingston from the base of the covered Market Street Bridge spanning the Susquehanna River. The Wyoming Valley Hotel replaced the Phoenix Hotel built by George Matson Hollenback in 1831. Maj. Orlando Phoenix was the Phoenix Hotel's first proprietor. The steamboat *Hendrick B. Wright* was launched in 1874 at the River Common, and it was destroyed by ice in 1881. The steamboat *Susquehanna* exploded at the base of the Market Street Bridge in 1883.

TROLLEY ON WEST MARKET STREET IN WILKES-BARRE, 1889. This image was taken facing towards Public Square, with the Luzerne County Courthouse in the background. The first electric trolleys ran on the Parsons, Miners Mills, and Plains line in 1888–1889. Tracks for horse-drawn trolleys were laid across the wooden Market Street Bridge on June 25, 1866.

STEAMBOATS *GREYHOUND* AND *PLYMOUTH,* 1891. Above is a view down the Susquehanna River from the steamboat landing near the Market Street Bridge in Wilkes-Barre. The steamboats were docking at the base of the Wyoming Valley Hotel, and in the background was the home of William Lord Conyngham on West South Street. In 1902, steamboat captain Joel Walp abandoned the last steamboats, *Greyhound* and *Wilkes-Barre.*

DAVID EVANS INSIDE THE DL&W STATION OFFICE IN PLYMOUTH, 1898. The Delaware, Lackawanna and Western Railroad was formed on March 11, 1853, after the merger of the Delaware and Cobb's Gap Railroad with Lackawanna and Western Railroad. The Plymouth Station was on the Bloomsburg Branch of the DL&W. During the 1880s, railroad coal shipments increased by nearly a third due to the number of railroad-owned coal mining operations.

DS&S RAILROAD LOCOMOTIVE, 1900. This photograph of Delaware, Susquehanna and Schuylkill Railroad Locomotive No. 6 was taken at the Coxe Coal Company in Hazleton. Eckley B. Coxe, a graduate from the University of Pennsylvania, had studied at the Paris School of Mines and the mining school of Frelberg in Saxony. He became one of the most prominent coal operators in Pennsylvania. Eckley B. Coxe died of pneumonia on May 18, 1895. His estate was estimated to be worth $10 million. (Courtesy Edward S. Miller.)

THIRD ANNUAL BALL

—— of the ——

Street Car Men's Union

No. 164

OF WILKES-BARRE, PA.

Monday Eve'g, January 1, '17

COLUMBUS HALL

Wilkes-Barre, Pa.

STREET CAR MEN'S UNION NO. 164 BALL, 1917. The third annual ball was held at the Columbus Hall in Wilkes-Barre. The first annual ball coincided with the Wilkes-Barre Street Railway strike that lasted 14 months, from October 14, 1915, to December 15, 1916. The strike started with disputes between the Wilkes-Barre Railway owners and the trolley company employees over working conditions, wages, job security, and unionization. Employees were under the guidance of P. J. Shea, a leader of the Amalgamated Association of Street and Electric Railway Employees of America that was organized on September 15, 1892. Thomas A. Wright, manager of the Wilkes-Barre Railway, was unable to agree to the union's terms.

LINDBERGH LANDS NEAR COXTON YARDS, 1928. Charles Lindbergh (1902–1974) was flying from Detroit to New York City when he encountered heavy fog along the Susquehanna River, forcing him to make an emergency landing on June 23, 1928, at 7:45 that evening. He landed on a field that went from Duryea to the Lehigh Valley Railroad roundhouse at Coxton Yards near Pittston Junction.

FIRST FLIGHT FROM THE WILKES-BARRE WYOMING VALLEY AIRPORT, 1929. This photograph is of the inaugural passenger flight to Newark, New Jersey, on September 24, 1929. Seen here are, from left to right, Walter Nulter, Clyde Davis, Frank Baldwin, Frank Martz, Eda Grovy, Leonard Rudolph, Stew Platch, Vera Cassidy, D. D. Somers, W. T. Scureman, and Claude Miller. The Wilkes-Barre Wyoming Valley Airport opened in Forty Fort on June 22, 1929.

STEAMBOAT ACOMA AT THE HOTEL ONEONTA PIER ON HARVEY'S LAKE, 1906. The *Acoma* was built by William R. Osborn for the Lake Transit Company. The steamboat measured 75 feet long and 16 feet wide. The *Acoma* launched on June 29, 1905, and it catered to passengers traveling to the attractions around Harvey's Lake. John A. Redington was the proprietor of the Hotel Oneonta, which opened on April 14, 1898.

DL&W RAILROAD WRECK IN OLD FORGE, 1935. Delaware, Lackawanna and Western Railroad Locomotive No. 1128 and Train No. 26 derailed. The Liggett's Gap Railroad was incorporated on April 7, 1832; chartered on March 14, 1849; and organized on January 2, 1850. The Liggett's Gap Railroad was renamed the Lackawanna and Western Railroad on April 14, 1851. The DL&W Railroad was created by the merger of the Delaware and Cobb's Gap Railroad with Lackawanna and Western Railroad in 1853. (Courtesy Edward S. Miller.)

LVRR Freight Train approaching Dallas, 1939. Locomotive No. 1162 led the 10-car train pushed by Locomotive No. 2029 westbound to the Dallas station on February 14, 1939. The first steam locomotive reached Dallas on December 9, 1886. Direct passenger service from Dallas to Wilkes-Barre began in November 1891. Passenger service to Dallas was reduced to one train daily each way on December 19, 1928. (Courtesy Edward S. Miller.)

LVRR John Wilkes before its inaugural run on June 4, 1939. Locomotive No. 2102 and Train No. 28 were open for public inspection at the LVRR Station on South Pennsylvania Avenue between Northampton Street and Market Street in Wilkes-Barre. Locomotives No. 2101 and No. 2102 were reconditioned at the Sayre shops. Ten new Pullman Osgood-Bradley deluxe coaches were purchased for the train. The *John Wilkes* was painted in Cornell red and black with stainless steel and white trim. The train ran between Wilkes-Barre and New York City, making its final trip on April 26, 1958. (Courtesy Edward S. Miller.)

LVRR Locomotives No. 502 and No. 503 in Avoca, 1945. The new Lehigh Valley Railroad EMD FT locomotive set was returning to Coxton Yards after pushing a freight train up the Mountain cutoff to Mountain Top. The FTs were the first road service diesel locomotives purchased by the LVRR and were used in helper service eastward out of Coxton Yards. This allowed the LVRR to retire steam locomotives from helper service. (Courtesy Edward S. Miller.)

Smith Flying Service Souvenir, 1939. In the 1930s, K. Russell Smith (1904–1989) opened the Smith Flying Service at the Wilkes-Barre Wyoming Valley Airport in Forty Fort. He purchased one of the area's first seaplanes in 1936 and made weekend charter flights over Harvey's Lake from 1939 to 1961. In 1944, Smith purchased lakefront property on Harvey's Lake to build a hanger for his business. Smith sold the property to the Harvey's Lake Yacht Club in 1962. K. Russell Smith retired from flying in 1969 and closed the Smith Flying Service at the airport in Forty Fort.

CNJ LOCOMOTIVE NO. 907 IN WILKES-BARRE, 1946. The main line of the Central Railroad of New Jersey in Pennsylvania ran from Easton to Scranton. The CNJ was the result of a merger of the Elizabethtown and Somerville Railroad with the Somerville and Easton Railroad on February 11, 1849. Locomotive No. 907 was in front of the CNJ Station in Wilkes-Barre that was built in 1868 and closed in 1972. The former station is located at 33 South Wilkes-Barre Boulevard. (Courtesy Edward S. Miller.)

LVRR STATION IN RICKETTS, 1908. Ricketts was a booming lumber town from 1889 to 1913. The station closed in 1921 but was not torn down until 1950. At Ricketts, the Ganoga Lake Branch diverged from the Bowman's Creek Branch of the Lehigh Valley Railroad for a 3.85-mile trek to Ganoga Lake, the home of LVRR director R. Bruce Rickets. Northbound trains went from Lopez to Towanda. Southbound trains went from Mountain Springs to Wilkes-Barre.

D&H LOCOMOTIVE NO. 1220, 1947. Pictured above is the Delaware and Hudson Locomotive on the Wilkes-Barre Connecting Railroad Bridge between Plains and Kingston. The D&H Railroad originated as the Delaware and Hudson Canal Company that built a canal in New York from Kingston on the Hudson River to Port Jervis on the Delaware River. The Delaware and Hudson Railroad was incorporated on December 1, 1928. (Courtesy Edward S. Miller.)

AMERICAN FREEDOM TRAIN IN WILKES-BARRE, 1947. The patriotic red, white, and blue Pennsylvania Railroad diesel electric traveled to 48 states on 37,160 miles of track. The nationwide tour began its journey in Philadelphia on September 17, 1947, and ended in Washington, D.C., on January 22, 1949. Over three million visitors boarded the train at stops in 326 cities; the highest attendance in one day was 14,615. This photograph was taken in Wilkes-Barre on November 13, 1947. (Courtesy Edward S. Miller.)

LVRR Station in Luzerne, 1963. The station above was originally called the Upper Raub's Station when it opened in 1887 at the top of Bennett Street. The Bowman's Creek Branch of the Lehigh Valley Railroad provided passenger service and freight service. In 1936, all passenger service ended, except for excursion trains to Harvey's Lake. The Bowman's Creek Branch was completely abandoned from Luzerne to Noxen on December 22, 1963.

Lackawanna Railroad in Kingston, 1947. This is a photograph of the Lackawanna Railroad Locomotive No. 1140 and Train No. 1702 on the Bloomsburg Branch of the Delaware, Lackawanna and Western Railroad at the Kingston Station. It ran from Scranton to Northumberland along the west side of the Susquehanna River. At Northumberland, the DL&W interchanged with the Pennsylvania Railroad. (Courtesy Edward S. Miller.)

U.S.S. WILKES-BARRE WAR MEMORIAL, 1971. Congressman Daniel J. Flood (third from left) attended the dedication of the bell and anchors from the *U.S.S. Wilkes-Barre* on the River Common at the Luzerne County Courthouse. A native of Hazleton, Congressman Flood represented Luzerne County in the U.S. House of Representatives for more than 30 years, from 1945 to 1947, 1949 to 1953, and 1955 until 1980. To revitalize the area, he sponsored the Area Redevelopment Act in 1961 and the Federal Coal Mine Health and Safety Act of 1969.

STEAM SHOVEL IN TRUCKSVILLE, 1939. Pictured is construction on the Dallas and Kingston Turnpike (later State Route 309) from the service station at the intersection with Pioneer Avenue. The Harris Hill Road stone bridge in the background on the left was originally built with two arches for the trolley line and Toby's Creek. After the Wilkes-Barre Railway discontinued trolley service, the bridge was rebuilt with one arch to accommodate Toby's Creek. (Courtesy Roger Samuels.)

NORTHERN LUZERNE COUNTY FAIR IN WAVERLY, SEPTEMBER 25, 1861. The Lackawanna and Bloomsburg Railroad provided passenger service to the fair from Kingston and Wyoming for $1, as well as from Pittston for 90¢. The Honorable Daniel Stevens Dickinson (1800–1866), former U.S. senator from New York, gave a speech at the fair. Dickinson, a War Democrat during the Civil War, had given a speech about the abolition of slavery in Cortland Village on September 3, 1861. The Lackawanna and Bloomsburg Railroad ran on 80 miles of track between Scranton and Northumberland, carrying coal and iron ore to support the iron industry in Bloomsburg. In 1867, the railroad transported 269,564 passengers.

WATER STREET BRIDGE LOOKING TOWARDS PITTSTON, 1914. Behind the wheel of his 1914 Studebaker touring car was Harry B. Schooley Sr. (1869–1953) on the West Pittston side of the bridge. Notice signs on the bridge read, "Due to repairs, heavily loaded vehicles are prohibited from use of this bridge and are directed to use the ferry bridge" and "Any person riding or driving over this bridge faster than a walk, will become liable to a fine of not less than $5 or more than $30 as provided by law." This photograph was taken before the bridge was closed and replaced by a 1,016-foot truss bridge built by the Penn Bridge Company in 1914. Visible across the bridge in Pittston were the Howell and King Company; the twin spires of St. John the Evangelist Church; and the tower with scaffolding belonged to St. John the Baptist Church. Schooley became president of the Second National Bank of Wilkes-Barre, director of the Raub Coal Company, president of the Evans Colliery Company in Hazleton, and president of the Westmoreland Building Corporation. He served as a trustee for the West Pittston Library Association, Wyoming Seminary, and the Wyoming Historical and Geological Society, later called the Luzerne County Historical Society.

BIBLIOGRAPHY

Castrignano, Elena. *Wilkes-Barre*. Postcard History Series. Charlestown, South Carolina: Arcadia Publishing, 2008.
Hanlon, Edward F. and Paul J. Zbiek. *The Wyoming Valley: An American Portrait*. Sun Valley, California: American Historical Press, 2003.
Lindbuchler, Ryan L. *Gone But Not Forgotten: Civil War Veterans of Northeastern Pennsylvania*. Dallas, Pennsylvania: Offset Paperback Mfrs., Inc., 2001.
Owens Jr., Harold D. "The Bowman's Creek Branch of the Lehigh Valley Railroad." *Flags, Diamonds, & Statues*. Volume 13, No. 1, 1996.
Petrillo, F. Charles. *Steamboats on the Susquehanna: The Wyoming Valley Experience*. Woodbine, New Jersey: Quinn-Woodbine Inc., 1993.
Petrillo, F. Charles. *Harvey's Lake*. Wilkes-Barre: the Bookmakers, 1991.
Schooley, Frank Budd. *The Word*. Dallas, Pennsylvania: Payne Printery, 1971.
Wick, Harrison. *Greater Wyoming Valley Trolleys*. Images of Rail. Charlestown, South Carolina: Arcadia Publishing, 2009.
Wick, Harrison. *Pennsylvania's Back Mountain*. Images of America. Charlestown, South Carolina: Arcadia Publishing, 2009.
Wolensky, Robert P. *The Knox Mine Disaster, January 22, 1959: The Final Years of the Northern Anthracite Industry and the Effort to Rebuild a Regional Economy*. Harrisburg, Pennsylvania: PHMC, 1999.
Zbiek, Paul J. *Luzerne County: History of the People and Culture*. Lancaster, Pennsylvania: Strategic Publications, 1994.

Discover Thousands of Local History Books
Featuring Millions of Vintage Images

Arcadia Publishing, the leading local history publisher in the United States, is committed to making history accessible and meaningful through publishing books that celebrate and preserve the heritage of America's people and places.

Find more books like this at
www.arcadiapublishing.com

Search for your hometown history, your old stomping grounds, and even your favorite sports team.

Consistent with our mission to preserve history on a local level, this book was printed in South Carolina on American-made paper and manufactured entirely in the United States. Products carrying the accredited Forest Stewardship Council (FSC) label are printed on 100 percent FSC-certified paper.

MADE IN THE USA